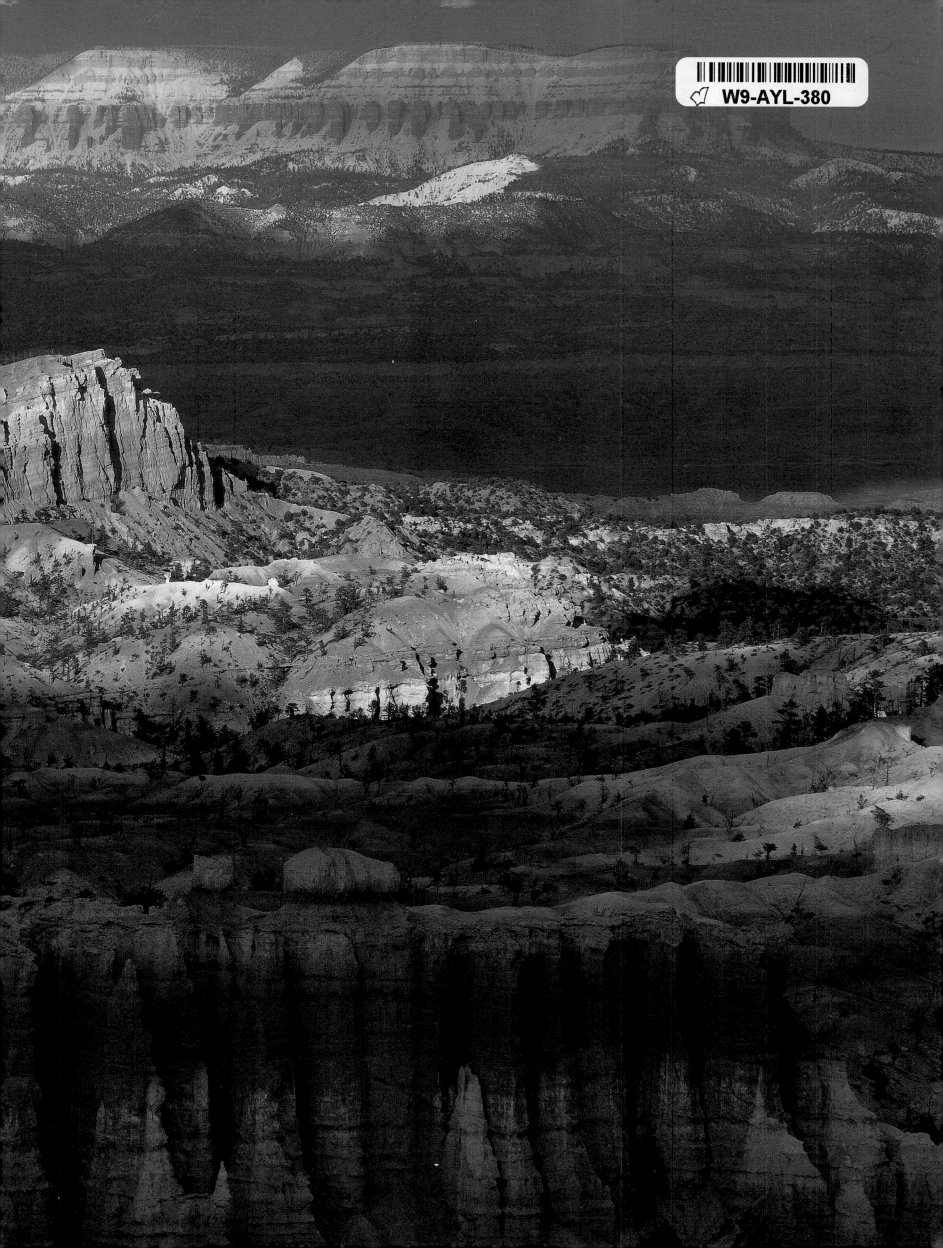

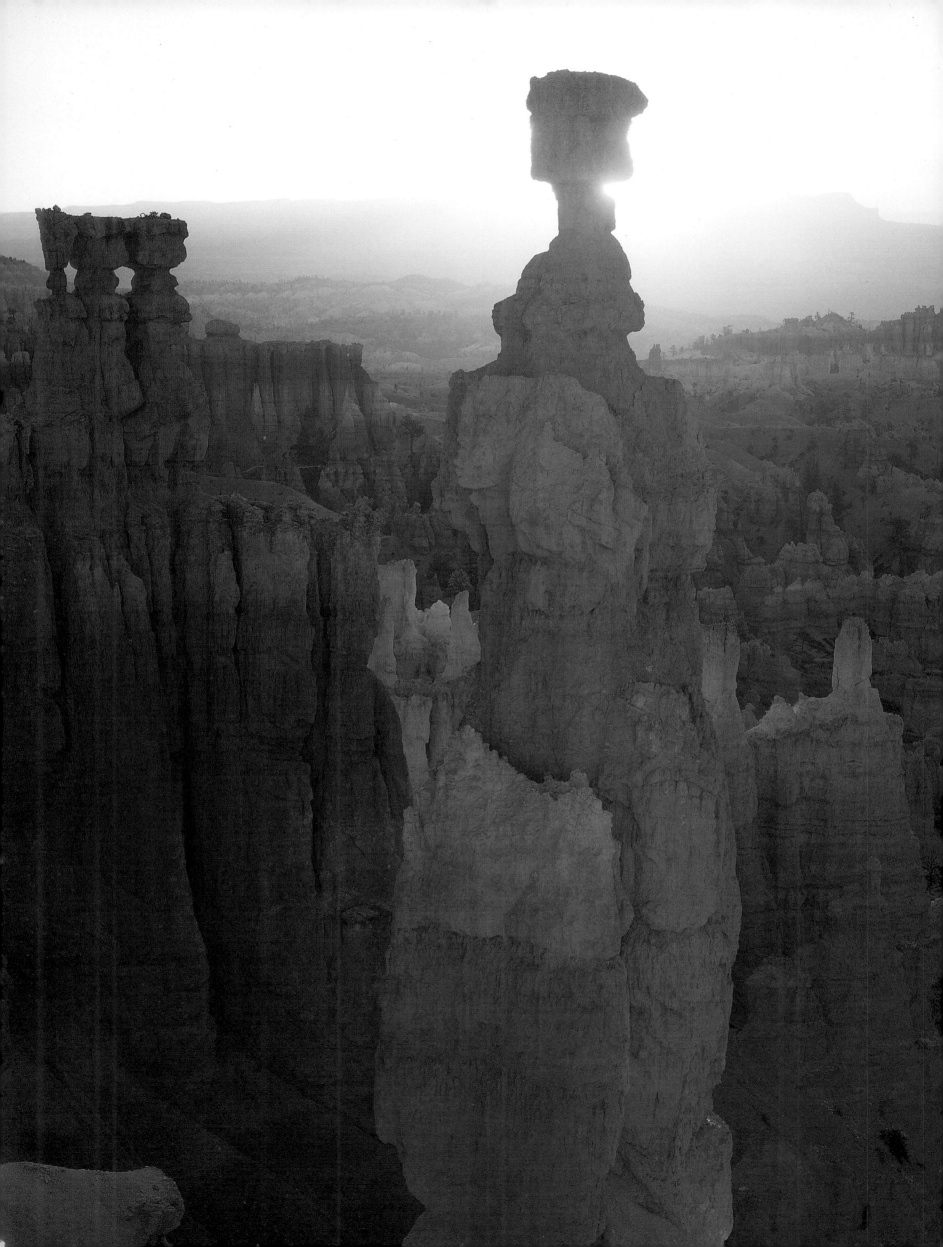

BRYCE CANYON

NATIONAL PARK

The Desert's Hoodoo Heart

BY

GREER K. CHESHER

SIERRA PRESS
MARIPOSA, CA

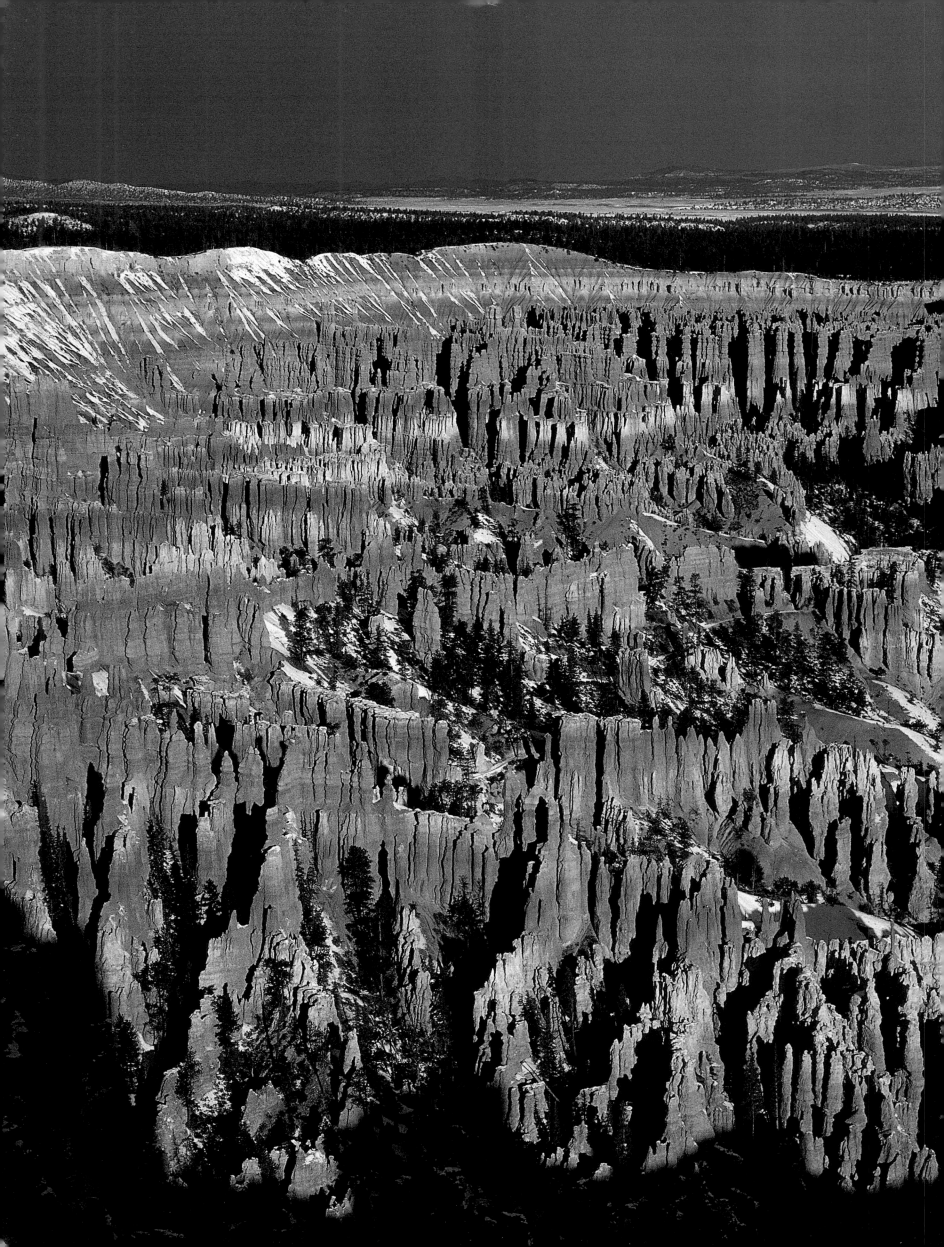

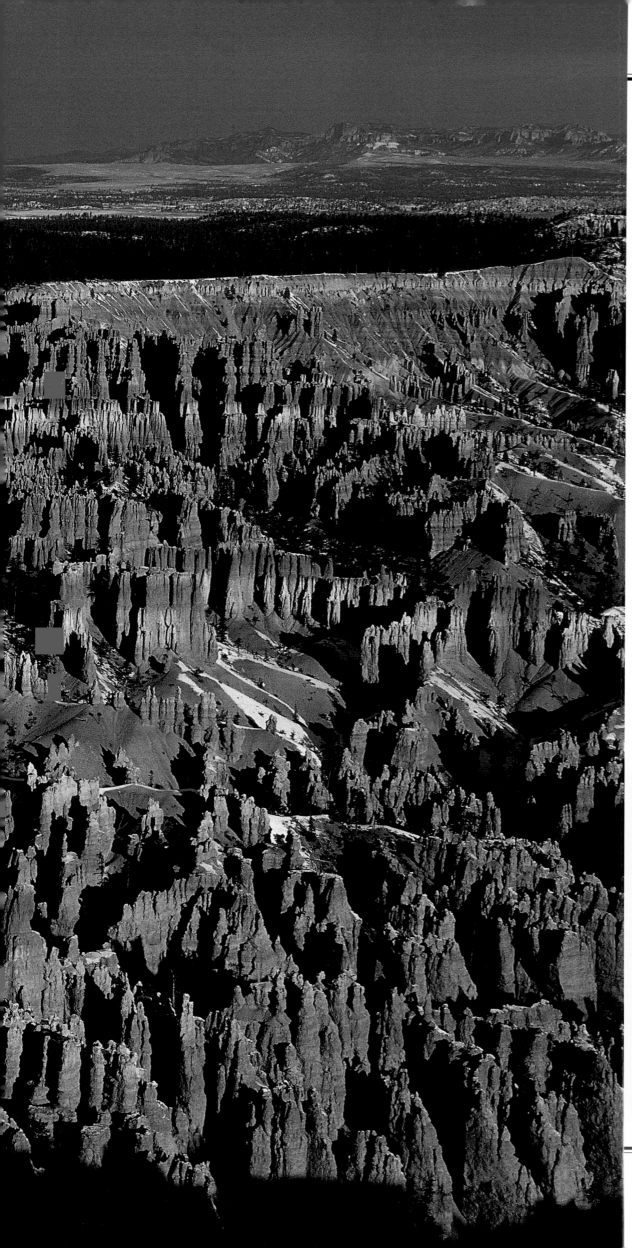

CONTENTS

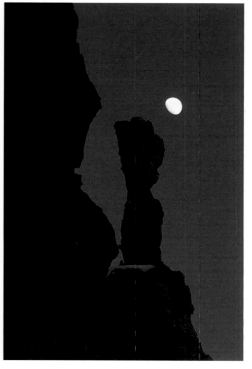

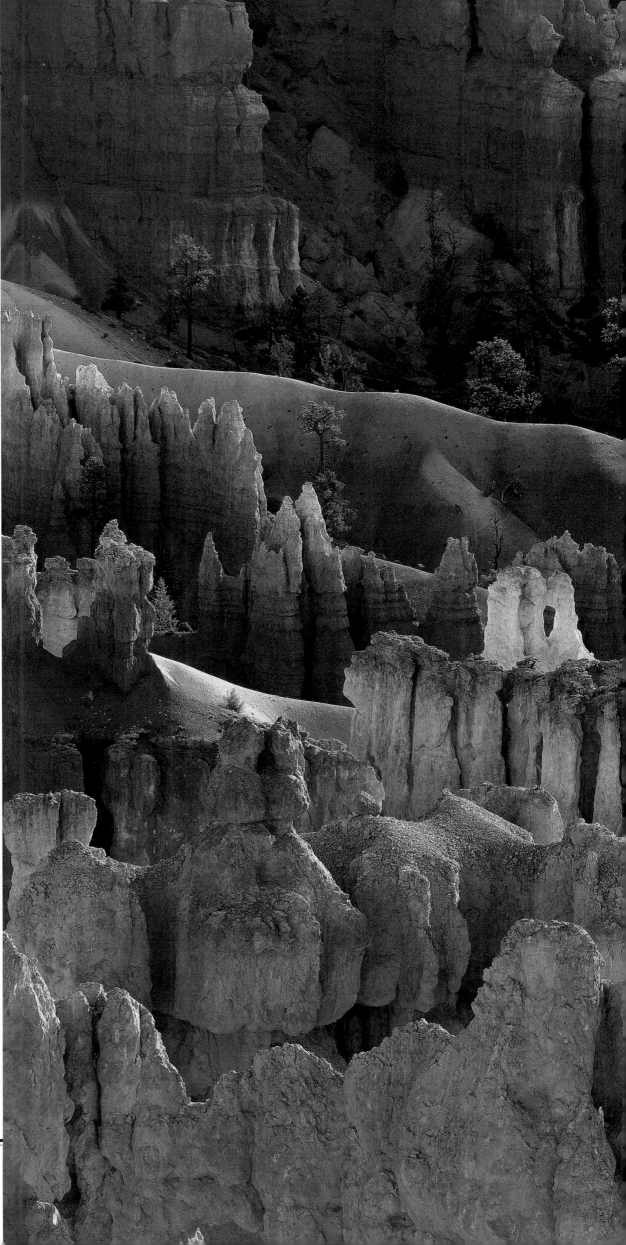

DEDICATION:

To Dorothy Rosina Elizabeth Myers Chesher
—A Brave Woman

ACKNOWLEDGMENTS:

Many thanks to Paula Henrie, Jim Wilson, and Jeff Nicholas who linked me with this project. Multitudinous thanks to Mimi Eckstein who would not let me sleep until I wrote like she knows I can (and who doesn't like the word multitudinous). Thanks to Jan Stock at Bryce Canyon National Park for checking the facts; and to my editor, Nicky Leach for making it all right. And special thanks to Bo the Adventure Dog, who unleashed me from my computer every evening and took me for a walk.

FRONT COVER:
Winter sunrise from Sunset Point.
PHOTO © LAURENCE PARENT
INSIDE FRONT COVER:
Dramatic afternoon light strikes Sinking Ship and Table Cliff Plateau. PHOTO © JACK DYKINGA
TITLE PAGE:
Thors Hammer, sunrise. PHOTO © JIM WILSON
PAGE 4/5:
Bryce Amphitheater from Inspiration Point.
PHOTO © FRED HIRSCHMANN
PAGE 5:
Moon and pinnacle, Navajo Loop Trail.
PHOTO © FRED HIRSCHMANN
PAGE 6 (BELOW):
Douglas fir and cliffs, Navajo Loop Trail.
PHOTO © BARBARA VON HOFFMAN
PAGE 6/7:
Pinnacles and spires in Queens Garden below Sunrise Point. PHOTO © GARY LADD

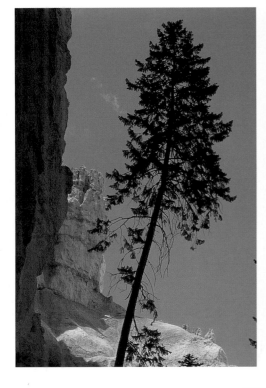

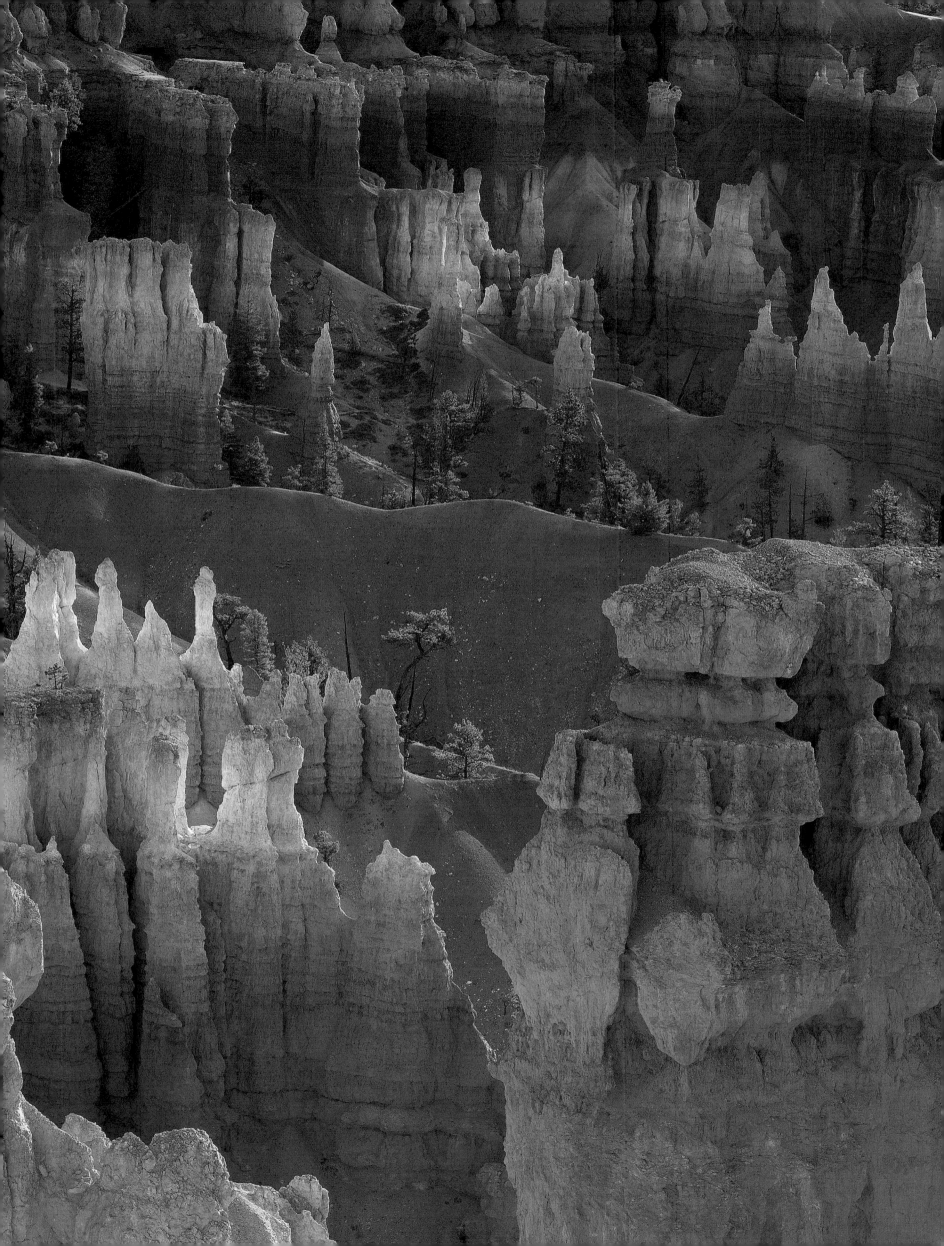

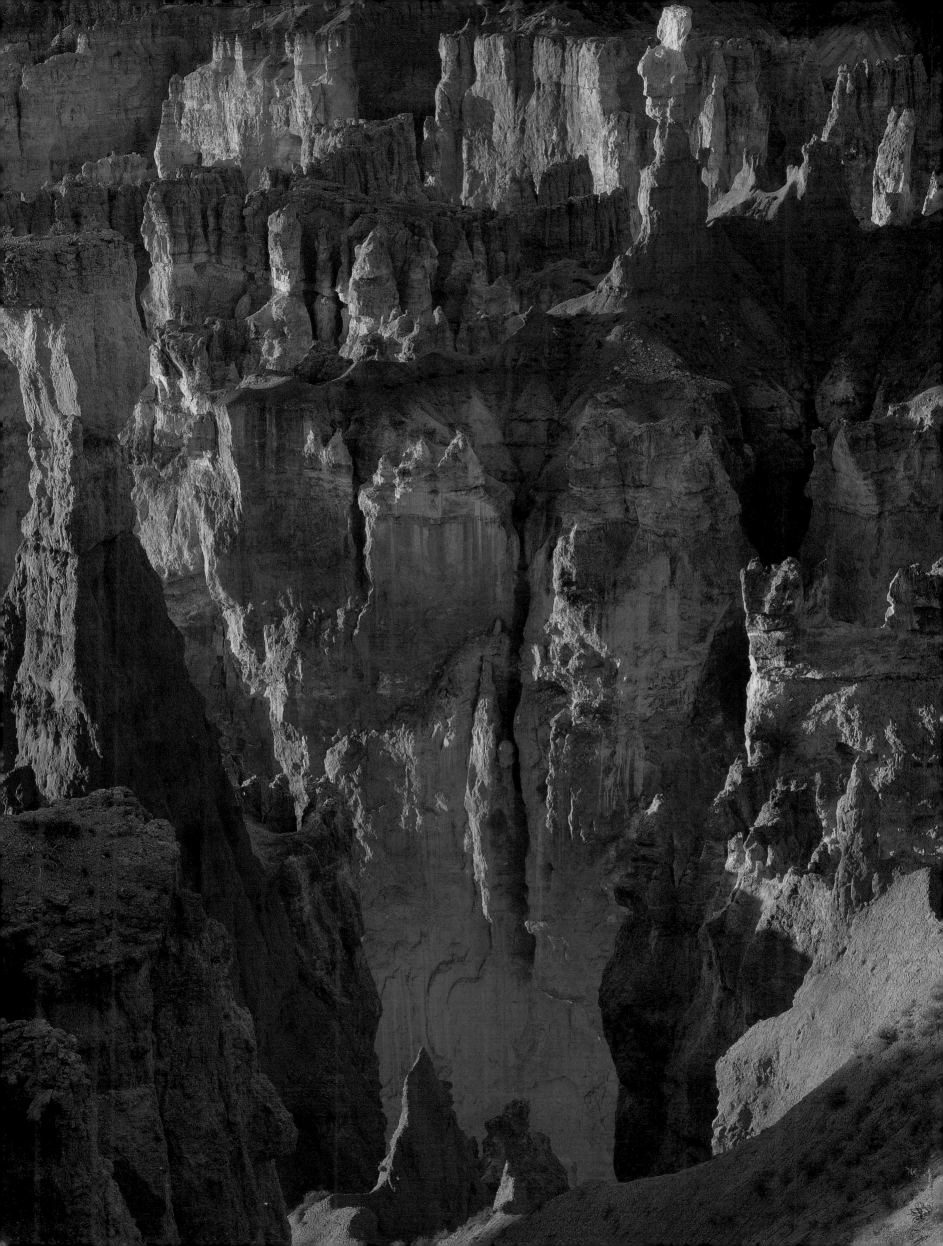

BRYCE CANYON INTRODUCTION:

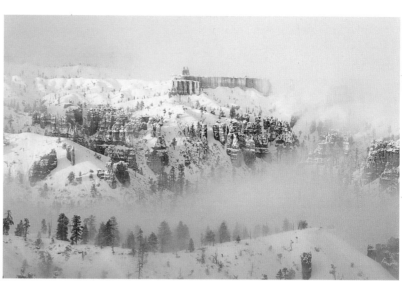

Pinnacles, spires, and fog below Bryce Point, winter afternoon. PHOTO © RUSS BISHOP

It is hot—the sun, blinding. This baked rime of desert wavers in the June heat, and wind pants through the passenger window. The car noses into the immense desert bowl of the San Rafael Swell on our journey to Zion by way of Bryce. I don't know what possessed my mother and I to do this, to drive cross-country together. It's been five days of haggling about driving habits (mine), windows (open or shut), the price of gas, and what food to eat.

But now, coming into this country, we are silenced. Our Michigan eyes brim with the West's amazement, bowled over by the wide openness of it, the unscreened nakedness. No trees, no lakes; just sky the turquoise of stone and land the terra cotta of jumbled pots.

As the land rises, my tiny car, having breathed only low-altitude air, chokes and stutters. Outside, pinyon and juniper trot by in this 4,000-foot high desert, at their feet, sea-green sage and white-flowering yucca. My mother, who has never been west of Chicago, is saying she doesn't think she could live in a place like this. I am on my way to work as a seasonal ranger at Zion National Park, and I am mesmerized.

Around us plateaus tier in creams, yellows, cinnamons, and maroons, their flat tops forest green, their toes bare. Dry canyons wiggle away from the road like snakes, like lightning. It's hard to keep my eyes on the road as the land peels to the bone. Sharp ridges jut like elbows; low hills arch like ribs. Cacti, tinged purple, poke from the rusty hardpan, and thin-skinned cows barely turn their heads at our passing. To the south, mountains rise, snow-capped blue sentinels in the burning desert. Signs proclaiming wonders tick by like fence posts—Arches and Canyonlands National Parks, Dark Canyon Wilderness Area, The Maze, Capitol Reef National Park, Anasazi Indian Village State Park. It appears we are circumnavigating the redrock heart of the world.

I ease the car to the roadside and spread the map across the steering wheel to get acquainted with the land: the mountains are the Henrys, and beyond them to the south the Colorado River pools in Lake Powell then splashes through Grand Canyon. Just north of the canyon on the map, Pipe Spring National Monument,

Zion National Park, and Cedar Breaks National Monument arc in a crescent tipped by Bryce.

As a Midwesterner, I had envisioned the Southwest as one giant desert. But today's landscape parade reveals a desert filled with multitudinous deserts, each strikingly similar, and each altogether different: redrock canyons, forested plateaus, sagebrush mesas, and an occasional green extravagance of seeps and springs. Each shift in elevation, moisture, rock, and sun barters pricklypear cactus for delicate cliffrose, or scrubby blackbrush for blue spruce.

Next, we climb the plateaus—Awapa, Aquarius, Sevier—heading for the Paunsaugunt, the plateau that holds Bryce above the desert's fray. Splendid ponderosa pines and not-yet-budded Gambel oak walk by as the car struggles to top the 8,000-foot plateau. We pull on sweaters as a mountain bluebird, the color of an iced pond, flits against the sunset sky. Clouds turn stony, the air more than cool, and when we reach the Bryce Canyon entrance station, we're staring, unbelieving, at snow whipping past the windshield. I'm beginning to understand that in the West elevation matters most when it comes to weather.

Determined to see Bryce, we head out along the scenic drive, but the thickening snow obscures every view. Near Natural Bridge, we climb from the car and glimpse, through a tiny portal in the blizzard, the stunning arch and, beyond, a watercolor of creams, pinks, yellows, salmons, golds, oranges, and bone standing in dazzling columns and towering spires. As the veil descends again, we cheer and laugh at our good luck.

My intention was to remain in the Southwest for the summer, but I've stayed 20 years. I have fallen in love with this place. In those two decades I've visited Bryce many times, retreating in summer's heat to its cool mountain freshness, wandering in fall through clamorous aspen lit like wicks, building snowmen in crystalline winters. And always just over the rim, stands the hoodoo forest of Bryce. (*Hoodoo*, by the way, is a serious geological term meaning "we don't know what else to call them," and refers to bizarre shapes eroded from stone).

Although most people focus on those unbelievable hoodoos,

OPPOSITE: Cliffs glowing in early morning light, Agua Canyon. PHOTO © TOM TILL

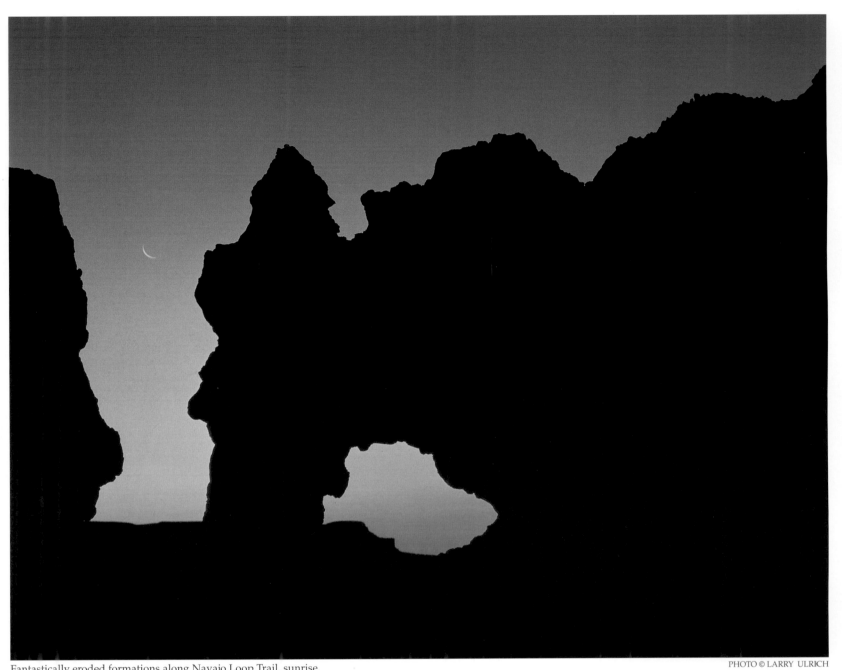

Fantastically eroded formations along Navajo Loop Trail, sunrise.

there is much more to Bryce. Behind the rim, burgeoning forests harbor ancient lives and unexpected creatures. Near Yovimpa Point, a single bristlecone pine has lived 1,600 years. Yellow-bellied marmots and blue grouse, usually found in more northern climes, find Bryce's high plateau a perfect home. Along the rim, the view is like no other, seeing into the Colorado Plateau's redrock soul. At night, bats flicker against a Milky Way bright as a river of stars, while below the rim, hoodoos dance in light and time on pedestals made of stone oceans and dinosaur bones.

Bryce has much to offer when we take the time to see. I often show a photograph of a woman standing in a blizzard laughing. I say, "This is my mother at Bryce." My friends look quizzically as I laugh, too. Behind her stands only a curtain of snow. But I still see the gift Bryce gave us, a taste of the beauty behind the veil.

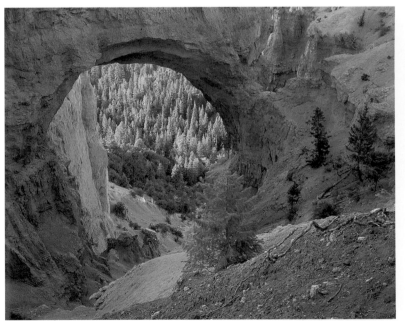

Early morning at Natural Bridge.

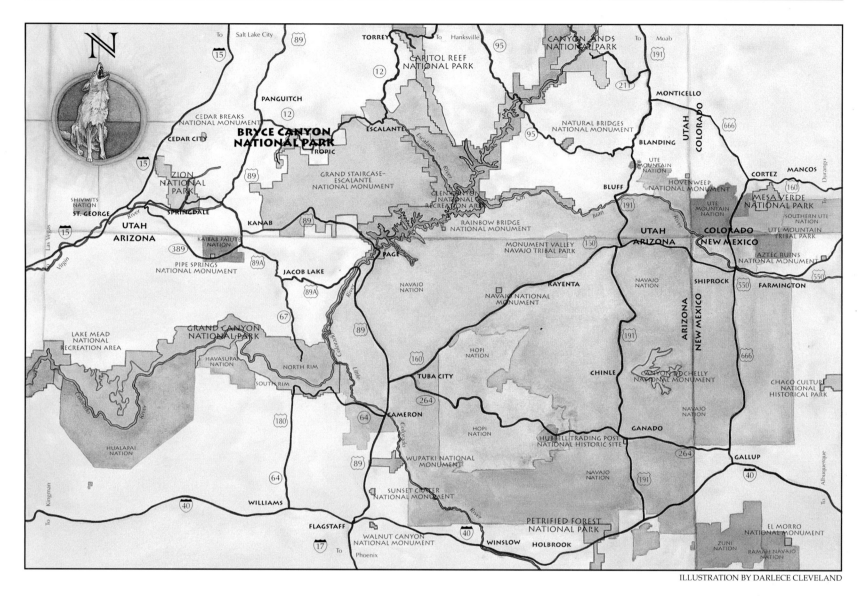

ILLUSTRATION BY DARLECE CLEVELAND

Bryce Canyon National Park seems an oasis of beauty and stillness in a vast desert. And so it is. But Bryce is also embedded in one of the most spectacular regions in the world. Within a 250-mile radius lie 12 national parks, 14 national monuments, seven tribal parks, 17 wilderness areas, seven state parks, and six national forests. Although these areas cluster on a map, each is distinct. Zion National Park reveals massive redrock cliffs; nearby Cedar Breaks National Monument balances slender hoodoos like a tray of delicate china. Petrified Forest National Park exposes an ancient forest teeming with dinosaurs, while Pipe Spring National Monument guards a pioneer fort. State parks brim with blazing coral pink sand dunes, Kodachrome landscapes, and wild goblins. Traders still trade in historic posts, and the enduring presence of native peoples lingers in the land.

This abundance of spectacular landscapes falls within a physiographic province known as the Colorado Plateau. Stretching from northwestern New Mexico, through western Colorado, into eastern and southwestern Utah and northern Arizona, this 130,000 square-mile plateau shoulders nine smaller plateaus known as the High Plateaus of Utah. One, the Paunsaugunt, erodes to form the remarkable amphitheaters of Bryce.

The high plateaus formed as deep geological forces uplifted the Colorado Plateau's flat sedimentary rock layers. Preexisting cracks broke the rising land into numerous immense blocks or *plateaus* that then elbowed to their current elevations. Remarkable landforms are unveiled as rain and snowmelt wriggle their way toward the Colorado Plateau's signature feature, the Colorado River.

This province has nurtured generations of peoples who surprise us with their ability to thrive in what appears to be an inhospitable land. Some walked this land with such grace that we find slight evidence of their passage. Others built semisubterranean houses of juniper and earth, and yet others, intricate stone houses. As the land changed, so to the people, each moving or arriving when the land called.

Now these places also call us. In the Bryce region, nine scenic byways provide access to the plateau's wonders. State Route 12 traces the northern boundary of Grand Staircase–Escalante National Monument, and U.S. Route 89 winds between the high plateaus. Major highways skirt the Colorado Plateau's edges: Interstate Route 40 its south rim, and Interstate Route 15 its west. Together these roads encircle a place like no other, a place where high plateau waters carve infinite beauty and grace, where ancient songs whisper, and strange hoodoos cast spells.

PAGE 12/13: Summer morning below Sunset Point, Navajo Loop Trail. PHOTO © GARY LADD

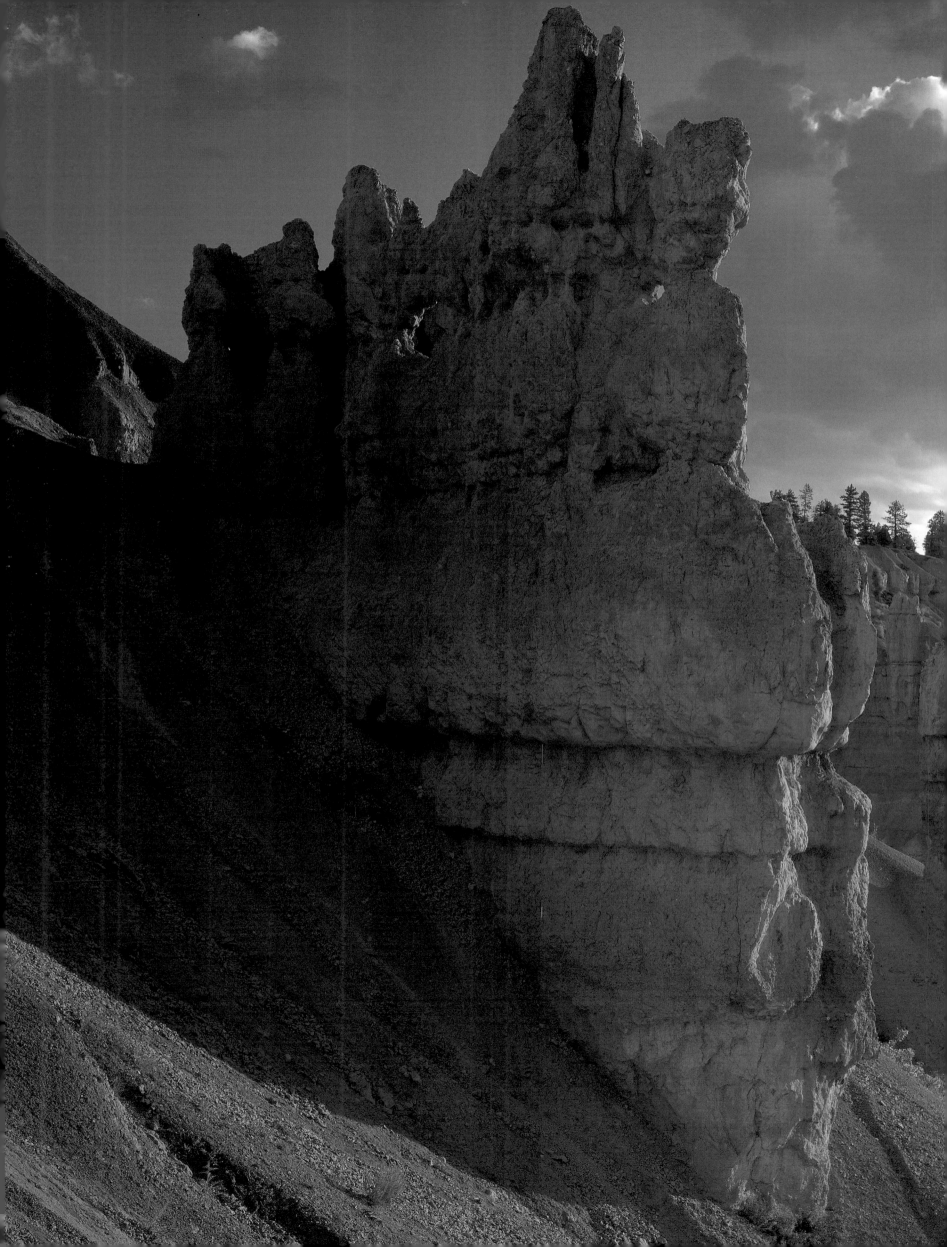

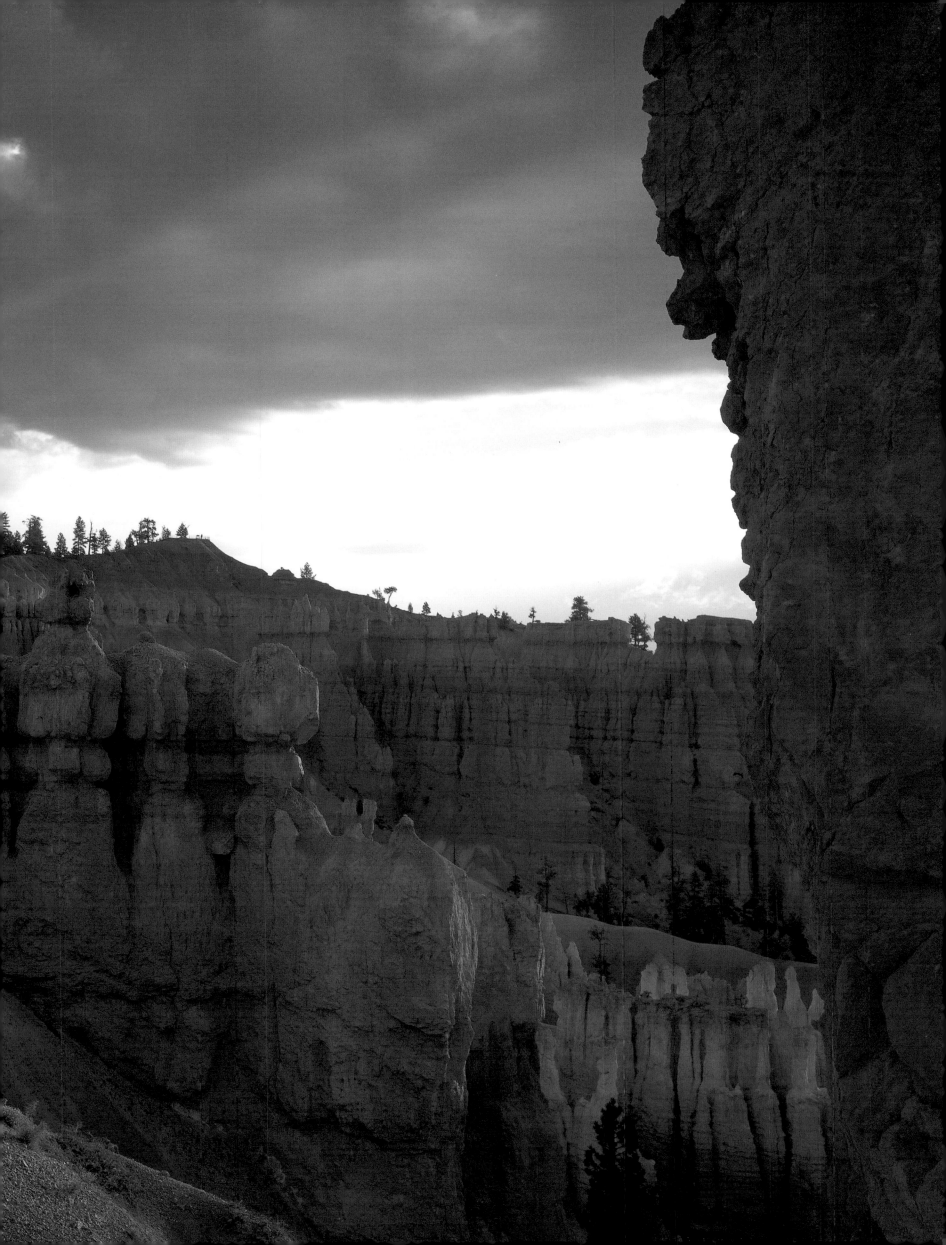

BRYCE AMPHITHEATER

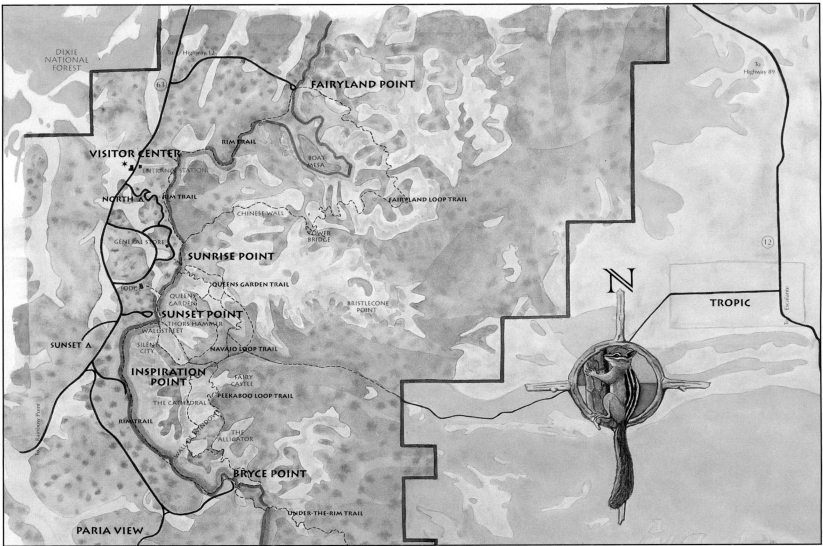

ILLUSTRATION BY DARLECE CLEVELAND

There's an odd thing about Bryce Canyon—it's not a canyon! It is, rather, a series of amphitheaters lined up like enormous bites from the Paunsaugunt Plateau's eastern edge. The most prominent, and probably most visited, is Bryce Amphitheater. Not only are the views fantastic, but the park's visitor services cluster here.

The **Visitor Center** offers informative exhibits, backcountry permits, ranger presentations, slide show, and bookstore. Be sure to pick up the park's free newspaper, Hoodoo, for more detailed information. Within two miles of the visitor center are **North Campground** (one loop remains open year-round), **Bryce Canyon Lodge** and restaurant, a **camper store**, **laundry**, **post office**, and **showers** (all open April through October). Check at the lodge for information on **horseback rides** below the rim. Farther along the scenic drive is **Sunset Campground**. From Bryce Canyon Lodge and both campgrounds, the amphitheater's rim is only a short hike along a pleasant path.

Within Bryce Amphitheater's embrace, four overviews—**Sunset**, **Sunrise**, **Inspiration**, and **Bryce Points**—provide exquisite views into a fiery cauldron of hoodoos. These points, accessible by vehicle and trail, also offer radiant sunset panoramas and black nights overflowing with stars. The **Rim Trail** (remember, rim elevations top 8,000 feet) connects these viewpoints. **Queen's Garden**, **Navajo Loop**, and **Peekaboo Loop Trails** begin in Bryce Amphitheater and allow hikers to drop below the rim to hobnob with their fellow hoodoos.

Standing at a Bryce viewpoint visitors can experience geology in action. Notice the slope of the land. The plateau's east side (below the rim) drops quickly to the nearby Paria River. The plateau's west side (behind the rim) gently slopes toward the distant Sevier River along U.S. Route 89. Precipitation falling between hoodoos carves deep canyons on its steep trip to the south-flowing Paria. Soon, the Paria joins the Colorado River and together they enter the Pacific Ocean in the Sea of Cortéz. However, precipitation falling on and behind the rim drains away from the amphitheater, and joins the north-flowing Sevier River only to evaporate in Utah's dry west-central desert.

In 1923, when Bryce Canyon was set aside as a national monument, only Bryce Amphitheater was included, and the monument's only road ended near Sunset Point. Bryce and all National Park Service areas were set aside to be protected unimpaired for "the enjoyment of future generations." So enjoy—and pass it on.

OPPOSITE: Deep winter snow in Bryce Amphitheater as seen from Sunset Point. PHOTO © RANDY A. PRENTICE

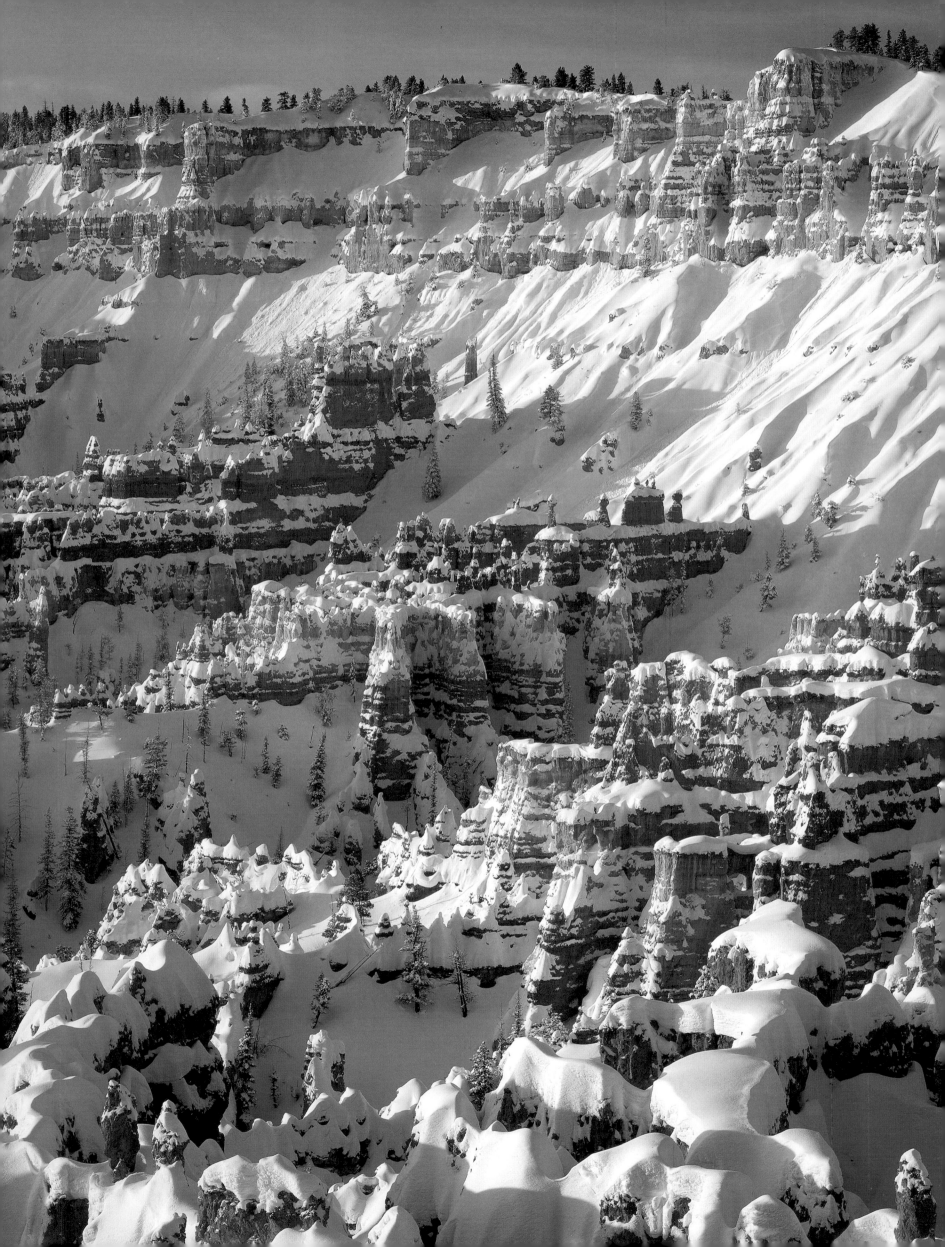

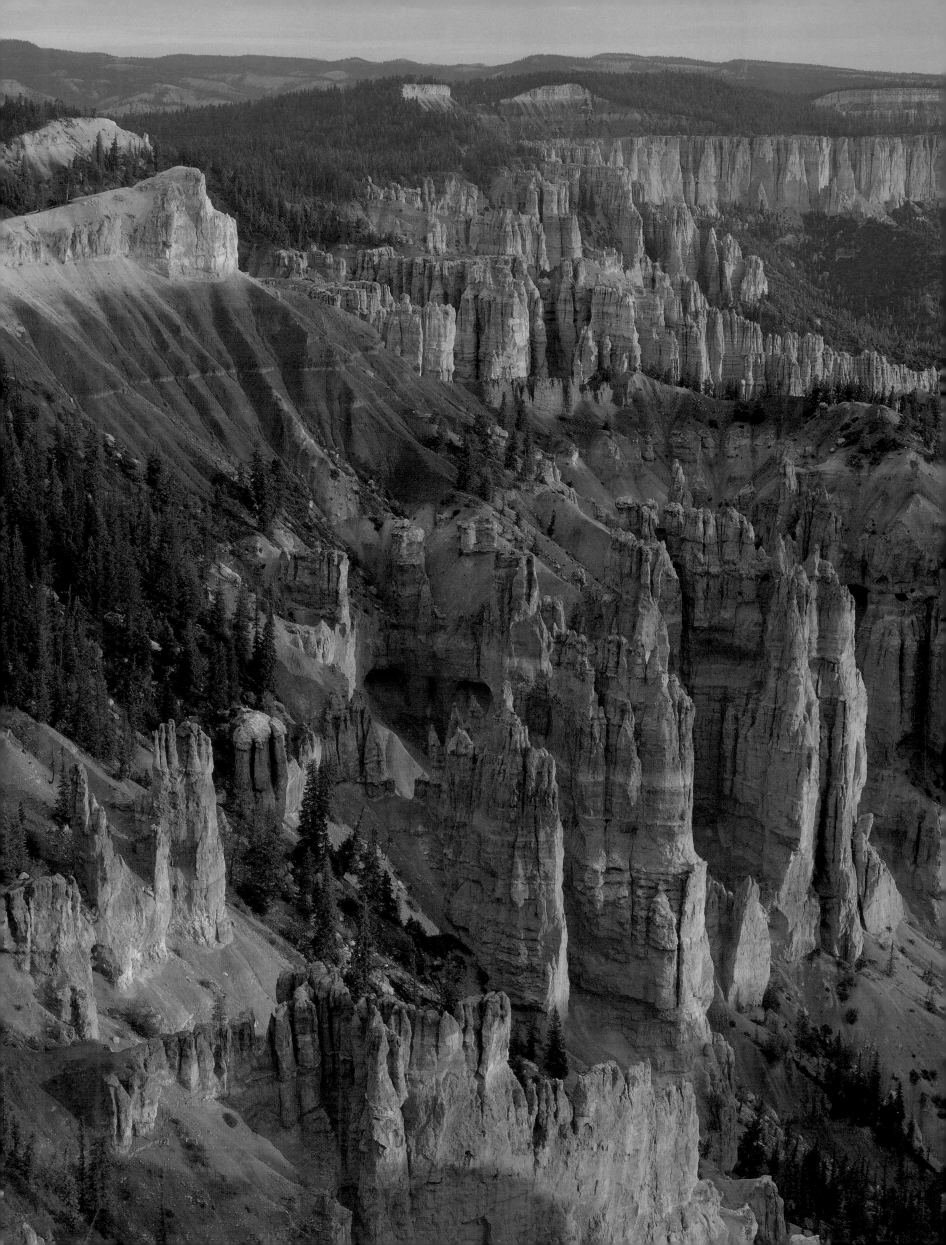

ATOP THE RIM:

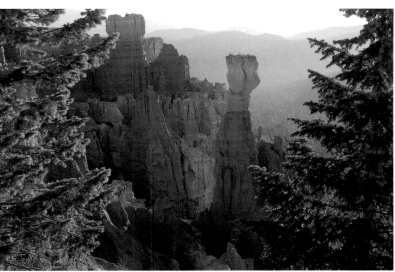

Douglas firs and The Hunter at Agua Canyon. PHOTO © FRED HIRSCHMANN

Lightning pulses red on the far plateau. Rain's long hair trails distant behind clouds tinged pink by the setting sun. Goosebumps dot my legs on this July evening, and I pull on an old, nubby sweater. Below, a silent riot of spires and pinnacles as delicate and finely painted as porcelain echoes the sky's tones. Behind me, a light rain begins in the pine forest, a hushed sssshhh. Turning, I notice a cloud the color of a violet-green swallow's back sneaking over Sunset Point. The monsoon season has arrived.

Most people associate monsoons with India and southern Asia, but similar wet seasons also pound the southwestern United States. Monsoons occur where prevailing winds reverse their direction seasonally. In late fall, early spring, and winter, weather blows into Bryce from the north, bringing, as Native Americans say, female rain—gentle showers and snow.

But during July, August, and September, winds shift and blow from the south and southeast. As moisture from the Gulf of Mexico consorts with desert heat, anvil-headed thunderstorms bloom. Suddenly, on any given afternoon, thunder grumbles and shouts over mesas, rain splats hard against slickrock, and canyons flood— male rain. In summer, hot and dry air rises in vortexing thermals from low deserts, spilling over Bryce, drying forest tinder, and worrying firefighters, for the monsoons bring not only humidifying rains but also explosive lightning.

Monsoon downpours are extremely localized, like water gushing from a showerhead. Too often canyon hikers are caught unaware when rain miles distant fills upcanyon tributaries. As waters accumulate, floods surge through dry streambeds, pushing boulders, logs, and trees downcanyon with the force of a speeding locomotive. The smell of mud and a sound like a distant jet airplane fill the canyon's light breeze just before the maelstrom bursts around a narrow bend. In Bryce, a lesser flush of waters yearly demolishes Wall Street's Navajo Trail, which is then painstakingly rebuilt.

During the 1880s, catastrophic monsoon floods ripped along southern Utah streams, destroying pioneer towns, ravaging crops, and trenching deep arroyos. Researchers think these larger-than-normal floods were triggered by offshore hurricanes or El Niño events and were abetted by thousands of cows, sheep, and horses that had stripped the land of retaining vegetation. Flashfloods, though dangerous, are one of the Southwest's major power tools, their sudden powerful blasts cut canyons faster than the daily sanding of clear waters.

The soft pink Claron Formation succumbs quickly to such forces, and thus current exposures are only remnants of its former extent. Geologists believe the layers of Bryce once covered what is now Zion National Park and that Zion's layers once covered Grand Canyon. Hypothetically, the waters of Bryce could cut straight down and dissolve the Pink Cliffs, incise a Zion Canyon through now-hidden layers, and then chisel a Grand Canyon; of course, this might take 50 million years or so. These three "canyons" differ in size because Grand Canyon is cut by the mighty Colorado River, Zion by the steady Virgin River, and Bryce by the fickle headwaters of the Paria River.

The 8,000-foot elevational change from the Bryce rim to Grand Canyon's basement allows for a remarkable diversity of environments in what appears to be one, large, undifferentiated desert. In Bryce alone, habitats range from forests of spruce and fir supporting blue grouse and yellow-bellied marmots to sere moonscapes nurturing turkey vultures and scorpions. In between lie broad meadows where prairie dogs tunnel and blue flax sway.

These treeless, sagebrush basins are troweled by abundant snowmelt and summer rain seeping not toward the Paria but westward down gentle slopes to the Sevier River (which parallels Highway 89). Before grazing began in the 1860s, these basins waved thick with native bunch grass, azure bellflowers, and golden cinquefoil. Now, opportunistic black sage, rabbitbrush, rubberweed, exotic grasses, and horsebrush dominate.

Elegant ponderosa and Rocky Mountain juniper often sneak into the meadow fastness, but rarely remain. In winter, cold air slinks into these slight depressions, dropping the temperature as much as 30 degrees Fahrenheit below that of the nearby forest and killing young trees. Although perhaps forever changed by the

OPPOSITE: The Pink Cliffs of the Paunsaugunt Plateau, dawn at Rainbow Point. PHOTO © JOHN TELFORD

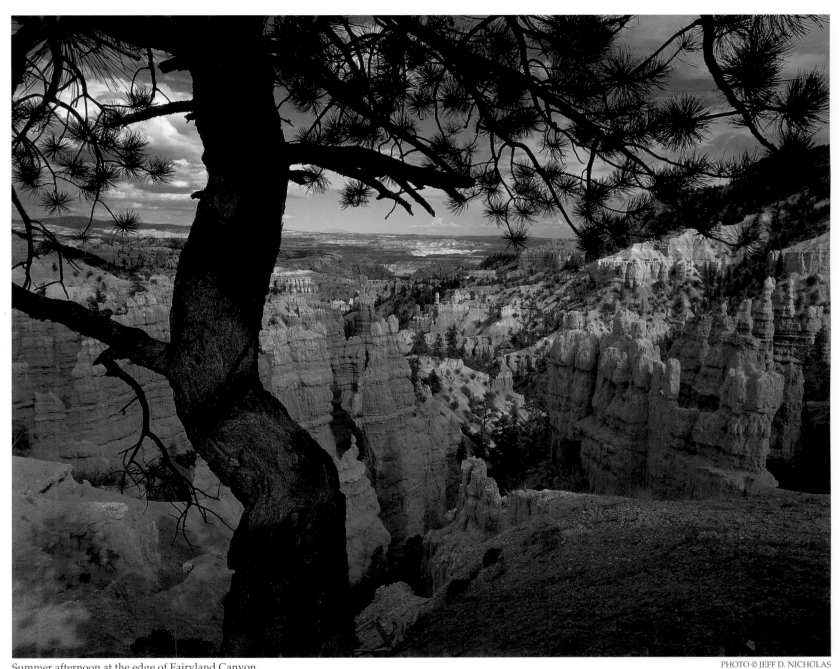

Summer afternoon at the edge of Fairyland Canyon.

impacts of grazing, these sagebrush flats still sing with summer wildflowers and rustle with mule deer, coyote, and endangered Utah prairie dogs.

Along the rim where I now stand, National Park Service resource specialists carefully measure sprawling common juniper, tiny purple-flowered Kentrophyta, and whatever grass they can find. According to their estimates, as much as 3 percent of vegetation disappears annually along the Bryce Amphitheater as millions of feet wander from marked trails.

As the isolated shower moves over the rim, people scurry for the shelter of their cars. Amazingly, for a little while, I have Sunset Point to myself. I breathe in the unmistakable musk of a ponderosa forest, the smell of rain, and stare into the brief silence. I catch a sound rarely heard, the sound of things in place.

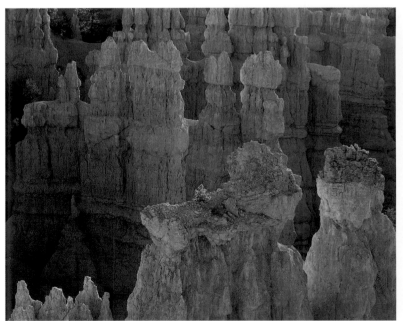

Pinnacles provide precarious perches for young trees.

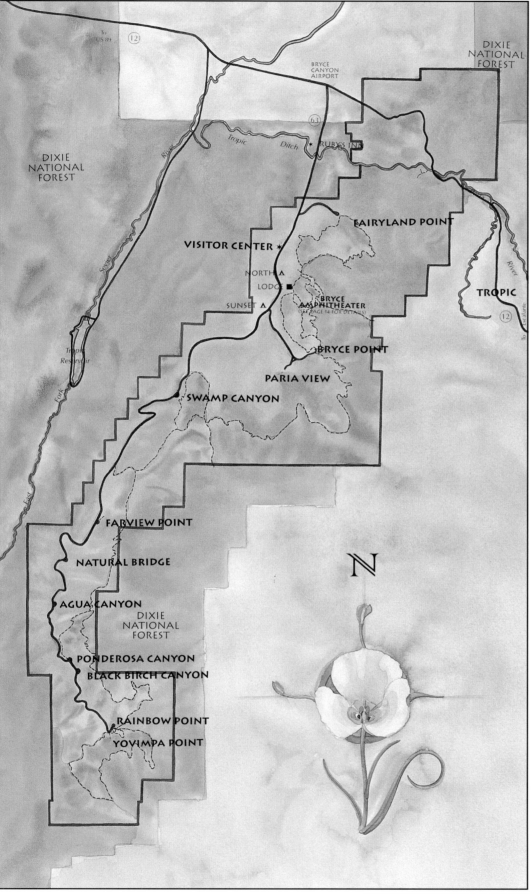

DIXIE NATIONAL FOREST

DIXIE NATIONAL FOREST

BRYCE CANYON AIRPORT

Tropic Ditch RUBYS INN

River

VISITOR CENTER ★

FAIRYLAND POINT

NORTH LODGE

BRYCE AMPHITHEATER (SEE PAGE 14 FOR DETAILS)

SUNSET

TROPIC

BRYCE POINT

PARIA VIEW

SWAMP CANYON

Tropic Reservoir

East Fork

FARVIEW POINT

NATURAL BRIDGE

N

AGUA CANYON

DIXIE NATIONAL FOREST

PONDEROSA CANYON

BLACK BIRCH CANYON

RAINBOW POINT

YOVIMPA POINT

ILLUSTRATION BY DARLECE CLEVELAND

From the Visitor Center to Rainbow Point, an 18-mile paved scenic drive winds along Bryce Canyon's rim providing 13 amazing viewpoints and a chance to see mule deer, hawks, and three different forests. Due to limited parking, the drive is closed to trailers beyond Sunset Point; campers should leave trailers at their campsites. Day visitors may leave trailers in the visitor center parking lot or in the trailer turnaround just south of Sunset Campground. Vehicles longer than 25 feet are excluded from Paria View, where they would be unable to turn around. In winter, heavy snows may cause temporary closures of the scenic drive.

By summer 2000, the National Park Service hopes to offer summer shuttle bus service for a fee. The shuttle will allow visitors to leave their cars or trailers outside the park, loop through Bryce Canyon, and disembark at viewpoints. Check the park's newspaper Hoodoo or website at www.nps.gov/brca for current information.

Perched on the rim of **Bryce Amphitheater** about a mile from the visitor center, **Sunrise**, **Sunset**, and **Inspiration Points** offer views of Bryce's best-known formations including Wall Street, the Silent City, and Thor's Hammer (remember elevations in this area top 8,000 feet). Other trails provide access below the rim. At the tip of the amphitheater's south horn, **Bryce Point** offers a look back at this giant bowl of hoodoos.

Paria View peeks into the next rim scallop, Yellow Creek amphitheater, and offers a glimpse of the meandering Paria River below. The scenic drive then stretches through open meadows and cool forests where sharp eyes may spot prairie dogs and wild turkeys.

The next six points rim the amphitheaters formed by the Willis Creek drainage. Near **Farview Point**, the drive begins a long ascent toward Rainbow Point; watch as the ponderosa forest slowly metamorphoses into a high-elevation spruce-fir-aspen forest. **Natural Bridge** boasts an impressive arch standing like the vaulted entrance to a medieval castle. **Agua**, **Ponderosa**, and **Black Birch Canyons** provide outstanding pinnacles and brilliant colors. **Rainbow Point** offers a panorama of the Colorado Plateau's incredible landscape.

A short, paved, and handicapped-accessible trail leads from the Rainbow Point parking area to **Yovimpa Point**. Yovimpa presides over the last Bryce amphitheater, Podunk, and is, at 9,115 feet, the apex of the Paunsaugunt Plateau.

Most visitors miss **Fairyland Point**, tucked, as it is, just past the entrance station when leaving the park. Be sure to stop on the way out for one last dose of hoodoo magic.

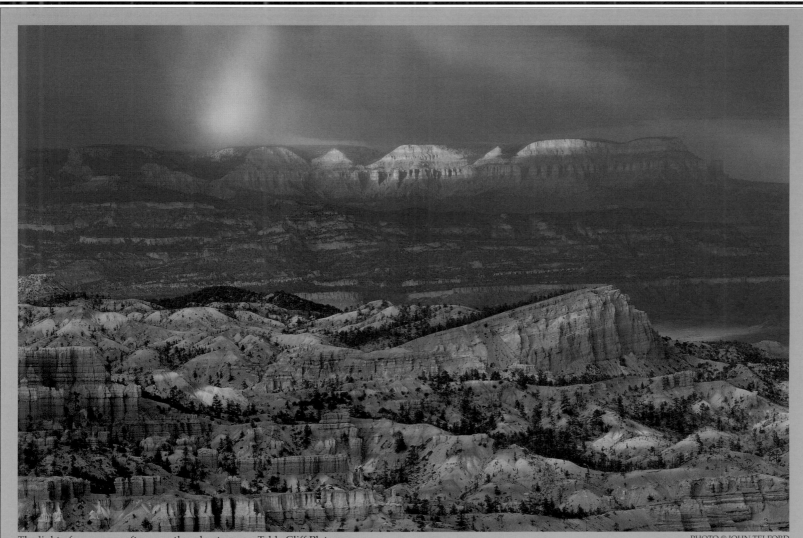
The light of a summer afternoon thunderstorm on Table Cliff Plateau. PHOTO © JOHN TELFORD

THE VIEW FROM HERE

Day or night, the views from Bryce are spectacular. Universes unfold above and below, both otherworldly. In this place famous for its pure dark nights, billions of stars burst like fireworks, and the Milky Way's spiral arms swirl like smoke. Unobscured so far by light pollution, and filled with a black velvet silence, the Bryce rim offers a place to lie back and dream.

Dawn kindles a fire in stone, and hoodoos rise like flames licking the rim. To the northeast, the Bryce-like Table Cliff Plateau, also known as Powell Point, marks the edge of one of the six major plateaus visible from Bryce, the Aquarius. To the north, the Sevier Plateau rumples the horizon, and to the east the Kaiparowits Plateau shears earth and sky. In the south, the Kaibab Plateau, into which the Colorado River cuts Grand Canyon, arcs blue-gray. To the west, the Markagunt Plateau holds the redrock Mukuntuweap, a place also known as Zion. Bryce itself cuts lavishly into the Paunsaugunt Plateau.

Day's light seeps into the White Cliffs below and illuminates the Paria River rippling toward its junction with the Colorado River, 50 miles south at Lees Ferry. Ninety miles distant, the indigo hulk of Navajo Mountain moors the sky's blue skirt.

The strong enlightenment of afternoon casts a different light. Landscapes blanch and cliffs blur behind a gauzy curtain. On too many days, Navajo Mountain disappears completely, and Table Cliff Plateau's radiant colors fall mute. Bryce, in its remote fastness, seems immune to city cares, but air pollution, wafting along the Colorado River conduit from Los Angeles and Las Vegas, knows no boundaries. Increasingly, local traffic and coal-fired generating plants confess their sins to the Anasazi air. Throughout the West, clear vistas are an endangered species.

Pinpricks of change shine in the dark night. A massive strip mine and coal-fired generating station planned for the plateaus below Bryce went up in a puff of smoke when Grand Staircase–Escalante National Monument was designated in 1996. Filling the view from Bryce, the monument stretches from the toe of the Aquarius Plateau to the foot of Navajo Mountain, and from beyond the spine of the Kaiparowits Plateau to the floor of Bryce; a wish on a shooting star come true. Only diligence and devotion to a planet without compare will fan such bright spots into constellations and galaxies of hope.

OPPOSITE: Sculpted hoodoo below Bryce Point in late afternoon light. PHOTO © GARY LADD

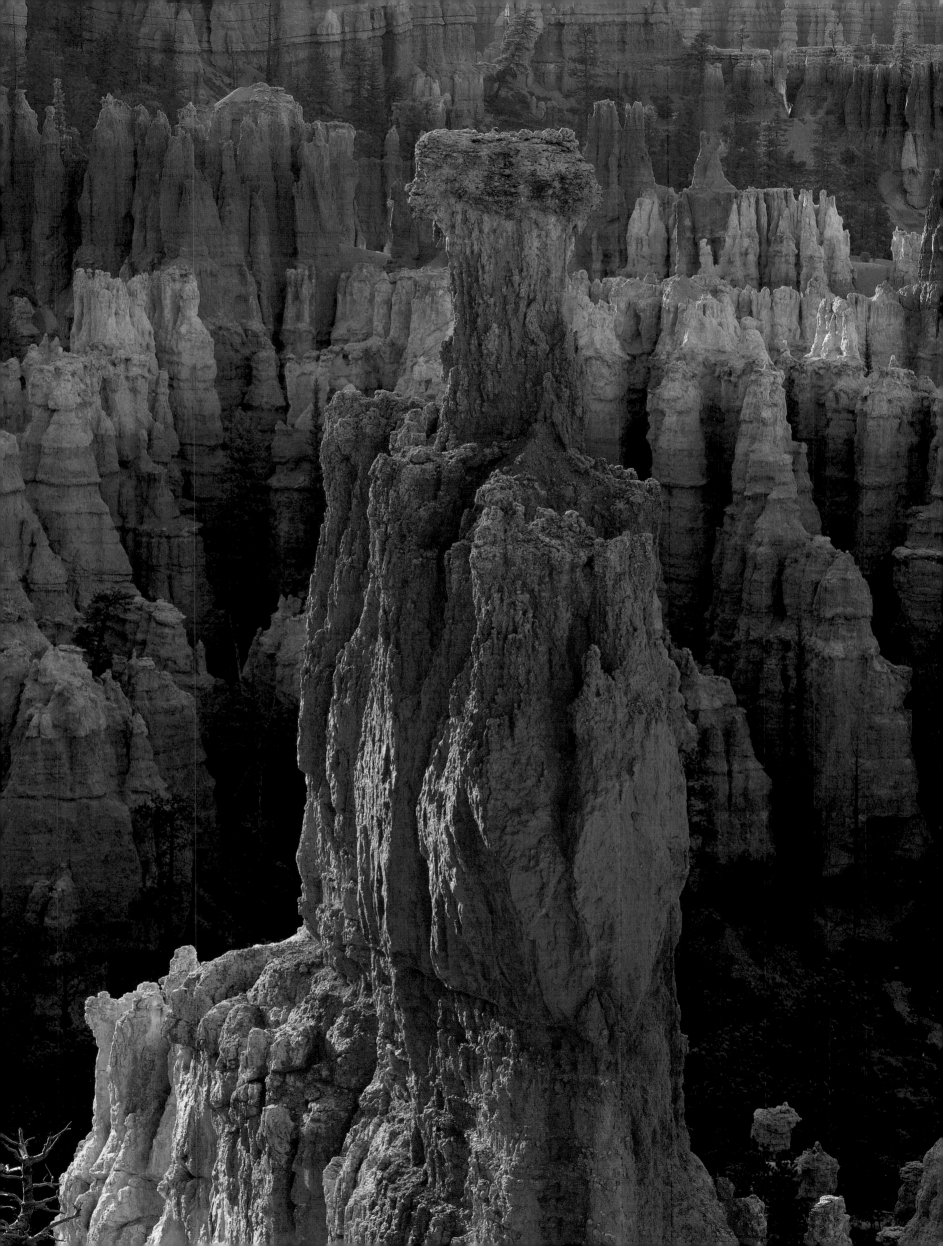

GEOLOGY

The geology of Bryce is as surprising as it is beautiful. Thors Hammer, the Silent City, Wall Street, Natural Bridge—each arose from the hands of the same relentless sculptor: small amounts of water falling over vast amounts of time. It is ironic, in this bone-drying desert where yearly precipitation averages a mere 16 inches, that water is responsible for shaping most of what we see. The geological formula at Bryce is basic; the details, fascinating.

To create a Bryce, **six elements** are necessary: first, an unusual material is needed in which to carve; in this case, it is the rosy pink **Claron Formation**. Then, the Claron must be **uplifted** above the surrounding landscape so that **sporadic precipitation** can gain the downhill momentum necessary to **erode** fantastic shapes. All this must take place in a **dry environment**; abundant rain would dissolve the Claron quickly, leaving a smooth hillside rather than freestanding pinnacles and sharp cliffs. Last, all these elements must be in place for a **very long time**. Anywhere these six specific elements transpire, Bryce-like formations will sprout. Just think of the delicate hoodoos of Cedar Breaks National Monument, the bold pillars of Red Canyon west of Bryce on Highway 12, and the luminous Table Cliff Plateau opposite Bryce.

The unique Claron Formation amassed 50 to 60 million years ago when the Bryce area lay at the bottom of a broad freshwater lake much like one of North America's Great Lakes. Sediments—limestone, mudstone, and sandstone—accrued as the lake precipitated calcium carbonate, accumulated materials from streams, and dried during periods of drought. These cycles, repeated over 10 million years, endure as interbedded layers cemented by more calcite (calcium carbonate) and the tougher dolomite (calcium-magnesium carbonate); together they build the 1,300-foot-thick Claron Formation. These various rock types and mortars disintegrate at different rates, sandstone slips away quickly, mudstone less so, and in the arid environment of Bryce, limestone persists—leaving hoodoos with jutting shoulders and skinny legs.

Between 10 to 15 million years ago, deep geologic forces began to elevate the Claron lakebed from near sea level to at least 11,000 feet. As the land rose unevenly, it ruptured along old lines of weakness, called faults, and left a bevy of plateaus at differing elevations, including the Aquarius Plateau, mirroring Bryce to the northeast, at 11,000 feet, and the Paunsaugunt Plateau, which holds the Pink Cliffs of Bryce, at 9,115 feet.

Below, the Paria River's course marks the Paunsaugunt Fault, the rift that separated Bryce and the Table Cliff Plateau. Because the Claron erodes, on average, one to four feet per century, it has taken one million years for the two plateaus to separate and retreat to their current locations. This means Bryce Canyon is not a canyon at all, but a series of amphitheaters scalloping the rim. Perhaps *Bryce Breaks* might be a more appropriate name to evoke the plateau's crumbling edge.

Amphitheaters are shaped by ephemeral creeks, branched like the fingers of a hand, running from the Bryce rim to the Paria River. From the viewpoints, these washes—Campbell Creek, Bryce Creek, Yellow Creek, and Willis Creek—often look like sandy roads. But when these streams fill with water draining the plateau, they cut not only myriad canyons but also file back the edge in a process known as headward erosion.

The Pink Cliffs form the top rung of an immense topographic feature known as the Grand Staircase. Below, and stepping down, come the Grey Cliffs, the White Cliffs, the Vermilion Cliffs, and the Chocolate Cliffs, portions of which are included in Grand Staircase–Escalante National Monument, Zion National Park, and Grand Canyon National Park.

The hoodoos, windows, bridges, and arches of Bryce develop as water plays along the plateau's rim. When uplift split the land along faults, it also generated a latticework of smaller cracks called joints. Into these clefts rainwater, which is usually slightly acidic, falls and easily dissolves the calcium carbonate cement, deepening joints into troughs and crevasses. The liquefied cement is then left behind on cliff faces by evaporating water and resembles wax dripping down a candlestick. Calcite can also wash down cliffs in broad sheets plastering the wall with a smooth stucco and armoring soft layers against disintegration.

Steep terrain affords rain and snowmelt the power to transport sand and gravel, abrading ever-deepening channels and leaving ridges, called fins, standing between. Hard dolomite layers cap these fins, shielding lower, softer layers. Fins eventually succumb, cracking along intersecting joints and leaving columns roofed by dolomite. As these pillars decay along points of weakness, Bryce's ornate spires, pinnacles, and hoodoos loom—then dwindle after losing their protective crowns. This "raindrop erosion" works in tandem with another process equally powerful. As Bryce's winter temperatures drop below freezing, water retained in cracks turns to ice and expands with enough force to wedge rocks from their perches. These freeze-thaw cycles occur more than 200 times each year at Bryce. At night, when ice reaches its full volume and pressure, rockfalls punctuate the silence.

Windows, like those along the Peekaboo Trail, open as water dissolves pockets and hollows in the Claron. When neighboring canyons thin a limestone fin in which such cavities exist, the hole's sides break through, leaving a window. Bridges soar as running water gnaws through pliant layers along a fin's base. Other processes play minor roles in the story; plant roots pry stony interstices and wind buffets rock with scouring blasts. There's also a force not usually considered; in 1986, lightning blasted the spatula-shaped hoodoo known as The

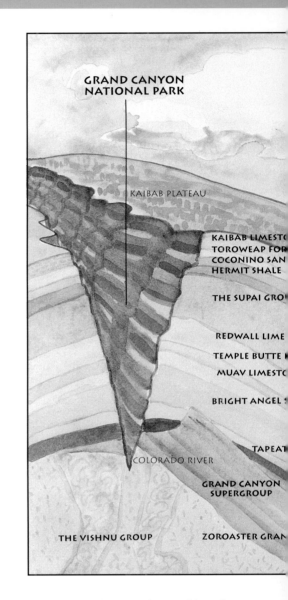

GRAND CANYON
NATIONAL PARK

KAIBAB PLATEAU

KAIBAB LIMESTO
TOROWEAP FOR
COCONINO SAN
HERMIT SHALE

THE SUPAI GRO

REDWALL LIME
TEMPLE BUTTE
MUAV LIMESTO

BRIGHT ANGEL

TAPEAT

COLORADO RIVER

GRAND CANYON
SUPERGROUP

THE VISHNU GROUP

ZOROASTER GRAN

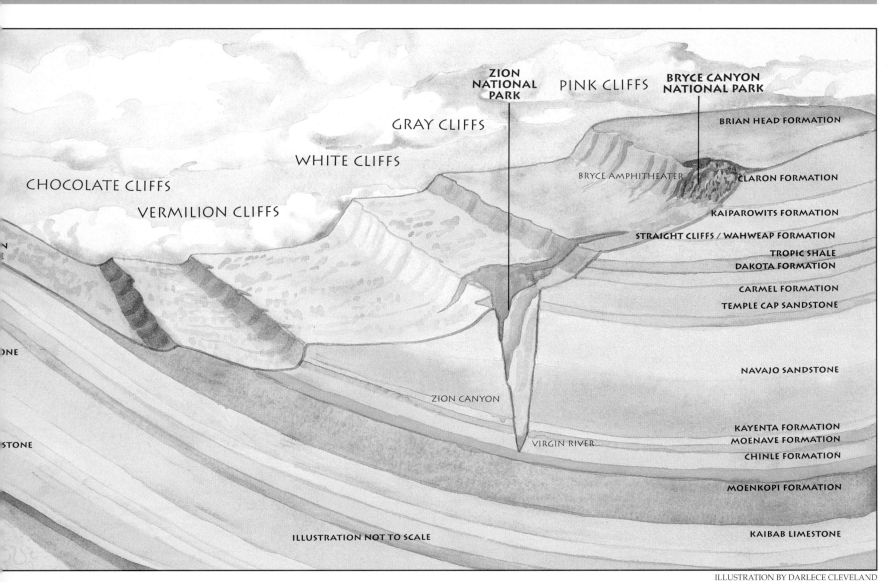

ZION NATIONAL PARK

PINK CLIFFS

BRYCE CANYON NATIONAL PARK

GRAY CLIFFS

WHITE CLIFFS

CHOCOLATE CLIFFS

VERMILION CLIFFS

BRIAN HEAD FORMATION

BRYCE AMPHITHEATER

CLARON FORMATION

KAIPAROWITS FORMATION

STRAIGHT CLIFFS / WAHWEAP FORMATION

TROPIC SHALE
DAKOTA FORMATION

CARMEL FORMATION
TEMPLE CAP SANDSTONE

NAVAJO SANDSTONE

ZION CANYON

KAYENTA FORMATION
MOENAVE FORMATION

VIRGIN RIVER

CHINLE FORMATION

MOENKOPI FORMATION

ILLUSTRATION NOT TO SCALE

KAIBAB LIMESTONE

ILLUSTRATION BY DARLECE CLEVELAND

Sentinel, exploding the multiton blade and leaving only a spindly handle. Bryce is also subject to small earthquakes that weaken hoodoos and cause rocks to fall.

The pigments that suffuse Bryce with such resplendent and uncountable colors seeped into the Claron when sediments accumulated. Minerals like iron and manganese now combine with oxygen in varying amounts to create iron and manganese oxides that dye hoodoos red, yellow, orange, rust, and brown and lavender, violet, and blue, respectively.

Although the Claron may be the most spectacular, it is not the only formation in Bryce. Underneath stack the Wahweap, Straight Cliffs, Tropic, and Dakota Formations, all deposited during the Age of the Dinosaurs, roughly 260 to 60 million years ago. These layers, collectively called the Gray Cliffs, appear as charcoal-colored slopes

below the foot of Bryce. They record tropical jungles, warm lagoons, beaches, and seaways in their coal, petrified wood, and in fossils of dinosaurs, turtles, crocodiles, and sharks.

The Gray Cliffs also contain many of the park's springs. Water absorbed by and percolating through the Claron limestone eventually hits less permeable shale or mudstone layers, and is then forced horizontally until it drips from cliffs. These springs were essential to the Paiute people who began living under Bryce about 500 years ago. Early ranchers depended on this aspect of the park's geology to water cows and crops, as do current visitors whenever they sip from fountains or enjoy a shower. In the 1920s, when Bryce visitation totaled 22,000 people yearly, these springs supplied the park's water. Now that visitation exceeds 1.6 million people annually, water must be pumped to Bryce from deep wells near the East

Fork of the Sevier River.

Although scientific concepts explain how hoodoos grow and colors form, nothing can quite explain the effect these geologic elements have on the human mind. Geologists can explain that the Henry and Navajo Mountains seen on the eastern and southeastern horizons are laccoliths, giant bulges of subsurface magma exposed as erosion peels overlying layers. But they can't quite explain why these violet-blue peaks swathed in the gold-rimmed ivory clouds of sunset make us catch our breath at the sight. Or why a pyre of luminous rocks flickering red, orange, yellow, and white with the force of a wildfire can inspire us to dream. Only our hearts can tell us that.

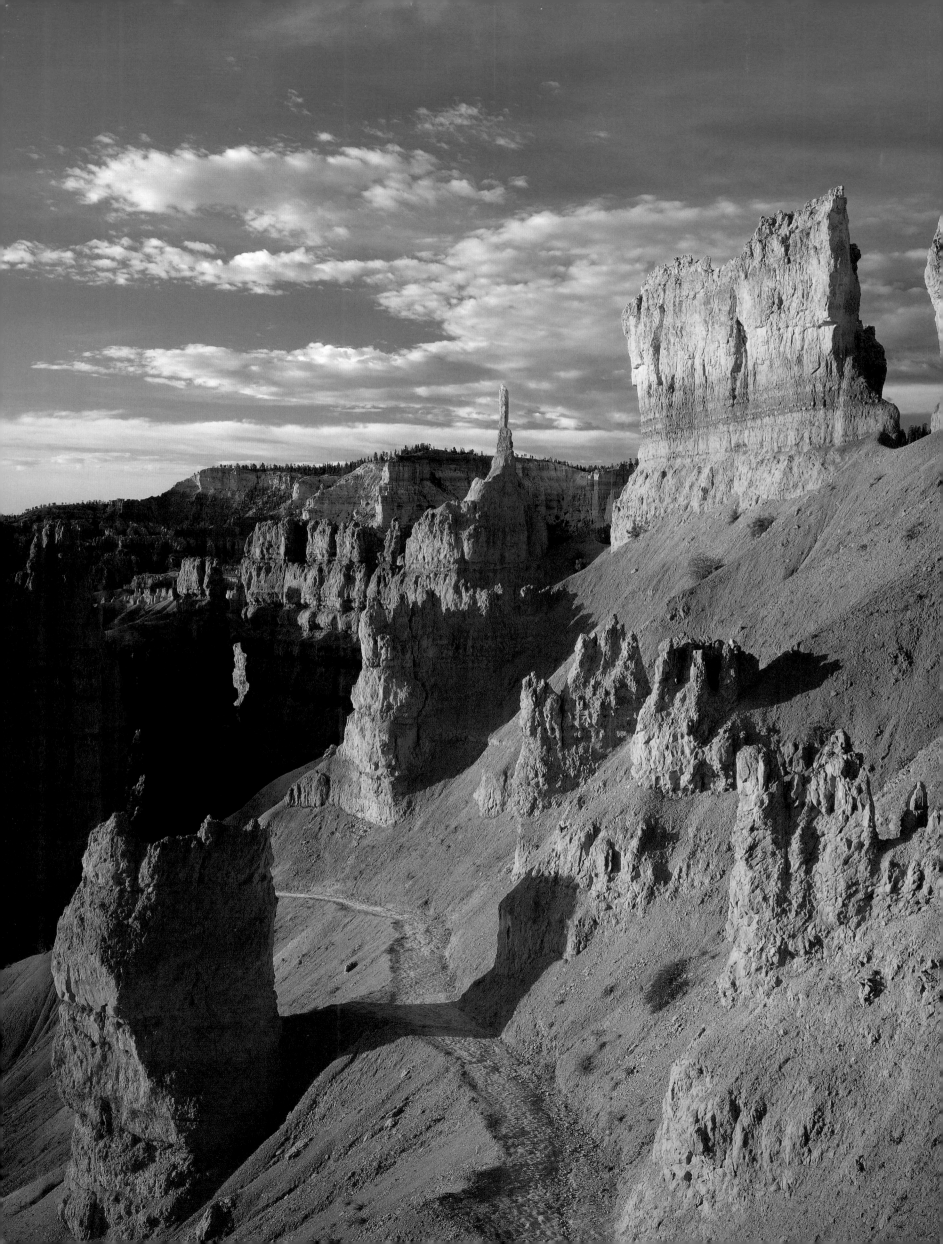

BELOW THE RIM:

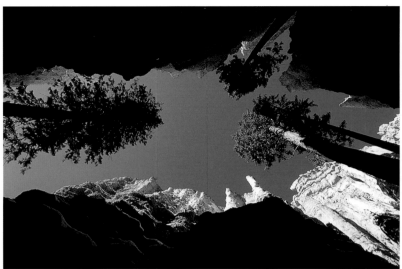

Douglas firs growing in Wall street, Navajo Loop Trail. PHOTO © RUSS BISHOP

I'm sneaking up on Bryce; not the Bryce most people see, but the one tucked at the hem of its pink skirt fringed the color of ripe cactus fruit. As I walk through the green coolness below the plateau's high point, just-hatched horned lizards scatter at my feet like fall leaves, their camouflage so perfect I see them only when they reveal themselves. Looking closer at their stony backdrop, I scan for any sign of what I've come to find, but my untrained eyes pick up nothing. I have come in search of the Ninwin who dwelled at a spring called *Piki-pa*, Seed Water.

I have always been fascinated with these quiet peoples, now called Southern Paiute, who are often lost in the glare of the glamorous Anasazi (now called the Ancestral Pueblo Culture). But when the Paiute arrived in this landscape from the west, they found hollow-eyed houses staring blankly from mesas and cliffs, and an environment healing from past overuse. The Ancestral Puebloans left this area after farming intensively for what were becoming overpopulated communities. The Paiute, however, centered their lives below the hoodoos around springs, lived in brush shelters, and combed the desert for sustenance; some bands cultivated modest streamside gardens. They built no permanent structures, no farms; but the Paiute were not, as it might seem, eking a miserable life from a harsh environment. They were, rather, right at home.

Before European-American settlement, Paiutes lived in extended family bands from Las Vegas to eastern Utah, each finely adapted to, and named for, the specifics of a certain place. There were, among many others, the *Pa-gu'-its*, the fish people, who fished from Panguitch Lake; the *U'-ai-Nu-ints*, the cultivators, who gardened along the Virgin River in what is now St. George; and the *Un-ka-ka'-ni-guts*, red-cliff-base-people, who lived under the Pink Cliffs in Long Valley. It is not clear which band claimed *Piki-pa*; it could have been the Kaiparowits people to the east or the Kaibab people near Kanab to the southwest. Presettlement, the Kaibab band totaled 5,500 people (amazingly close to the current population of the towns and ranches surrounding Bryce).

On my journey through this dense ponderosa forest, I've found no sign the Ninwin were ever here. As the forest opens into a wide meadow dotted with immense ponderosa and rippling with grass, I hear *Piki-pa* trundling into its small pool from a hillside burgeoning with Rocky Mountain maples tinged red, and white firs ever green. Sitting at the spring, enfolded in shimmering aspen, I realize I don't need to observe artifacts; I see the Ninwin in the land.

I see them in the full-headed meadow grasses from which daily flour came; I taste them as I nibble Nootka rose hips bright as cherries, and wax currants deep as ripened plums; and I hear them in the sound of pouring water. Their legacy lives in Utah's lingering wildness.

Noticeable also is the contribution of later European-Americans—but it is not what you might think. In this lovely, open ponderosa meadow, I see junipers and pinyon creeping down hillsides; piles of gray, weathered tree trunks; and exotic plants like red brome, cheat grass and tall, yellow-flowered goatsbeard skulking between—a habitat that looks completely natural, and some scientists call *naturalized*. But it is not what the Paiutes would have seen.

When European-Americans arrived in southern Utah, they recorded their amazement. Journals state how native grasses grew "belly-high on a horse"; early photographs show glades of immense ponderosas uncluttered by underbrush and sage, where pinyon and juniper stood high on hillsides, and native scarlet gilia flowers burst red as rockets. Into this refined environment came swift and overwhelming change as another round of farmers brought cultural traditions more exhausting than intensive agriculture: alien grazers (horses, cows, goats, sheep) that depended on Paiute springs and ate away their grasslands; and a dislike of fire. By the mid-1800s, the Kaibab band totaled 500, a 90 percent decline from presettlement numbers. Over 150 years, accumulated impacts leave us an environment so altered even the adaptable Paiute could not scrape up a living.

As I cross a dry creek, a warm sight greets me—a wildfire's blackened ground. There is nothing quite so beautiful as the stout green leaves of mountain lover pushing through a fire's cleansing ash. Robust and puzzle-barked ponderosas shine black with their

OPPOSITE: The Navajo Loop Trail passes The Sentinel below Sunset Point. PHOTO © GARY LADD

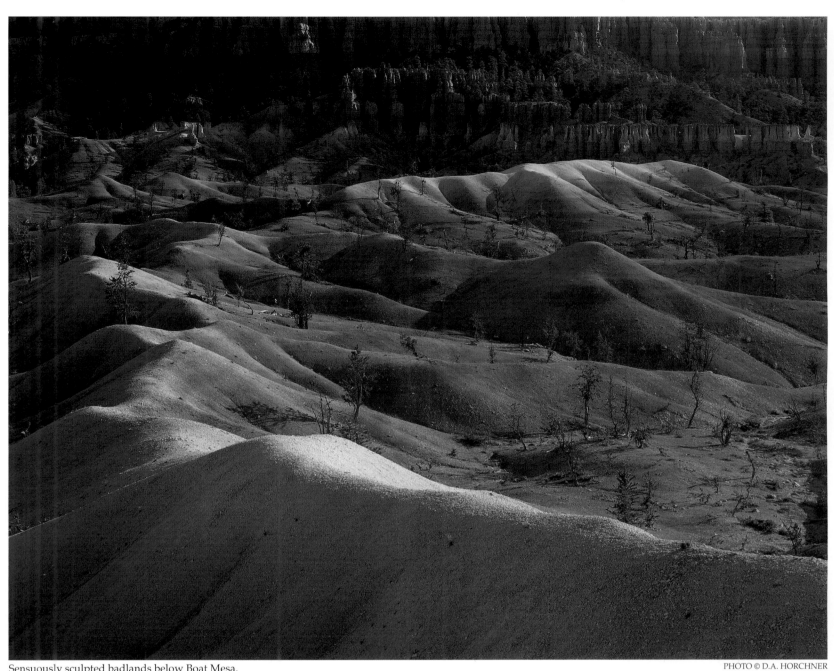

Sensuously sculpted badlands below Boat Mesa.

latest charring; their pine needles fall golden on the charcoal soil. I smile as a red squirrel chips a warning, and a doe mule deer stots away, then turns to look me in the eye. This was the perfect fire, a quick snap of lightning, then fire running along the ground through dried grass and wood, scorching lower branches and dead needles from trees, killing invading sage, juniper, and pinyon, rejuvenating understory shrubs, and beginning again the process of building a healthy forest.

As I place my hands in *Piki-pa's* bountiful flow, I realize I am beginning to see beneath the surface, seeing in this landscape an unbroken cord of human choices. I nod to the Paiute who understood, perhaps better than anyone, how to live in this place. Looking up, I admire the delicate-flowered Rocky Mountain clematis trailing among lingering native grasses. I smile to see pink-tasseled thistles, stalwart Gambel oak, and the little green apples of manzanita held in this pink crescent-moon of cliffs.

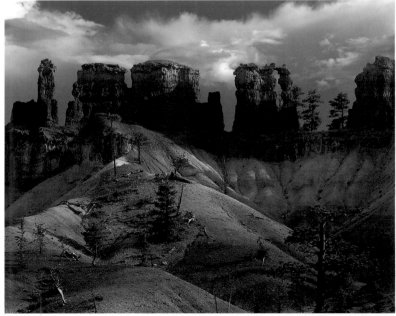

Spires and turrets in Bryce Amphitheater, late afternoon.

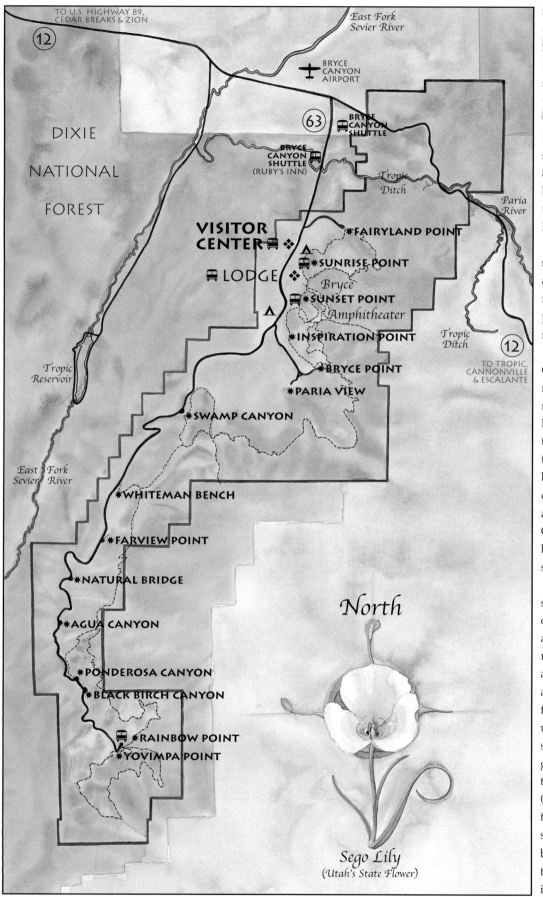

TO U.S. HIGHWAY 89, CEDAR BREAKS & ZION

East Fork Sevier River

(12)

BRYCE CANYON AIRPORT

(63)

BRYCE CANYON SHUTTLE

BRYCE CANYON SHUTTLE (RUBY'S INN)

DIXIE NATIONAL FOREST

Tropic Ditch

Paria River

VISITOR CENTER

*FAIRLAND POINT

*SUNRISE POINT

LODGE

Bryce

*SUNSET POINT

Amphitheater

Tropic Ditch

(12)

*INSPIRATION POINT

TO TROPIC, CANNONVILLE & ESCALANTE

Tropic Reservoir

*BRYCE POINT

*PARIA VIEW

*SWAMP CANYON

East Fork Sevier River

*WHITEMAN BENCH

*FARVIEW POINT

*NATURAL BRIDGE

North

*AGUA CANYON

*PONDEROSA CANYON

*BLACK BIRCH CANYON

*RAINBOW POINT

*YOVIMPA POINT

Sego Lily
(Utah's State Flower)

ILLUSTRATION BY DARLECE CLEVELAND

Standing on the Bryce rim, mesmerized by trumpeting colors and the beckoning maze, one hears the sirens call. Succumbing to their music one sinks below the rim in a reverence of song, and, arriving at the canyon's floor, suddenly remembers that what comes down must go up.

To avoid that sinking feeling, consider these tips. Hike below the rim half as far as tempted; save some spunk for the hike out. Because rim elevations range from 8,000 to 9,000 feet, even fit people may have difficulty breathing, or feel light-headed and drowsy. High elevations also mean intense sun and quick sunburns; wear hats and sunscreen and carry plenty of water.

Although Bryce is known for cooler temperatures, summer days top 80 degrees Fahrenheit on the rim and amplify below. Trails are steep and steeper, and loose rocks roll underfoot like ball bearings, causing unexpected posterior landings. The most common visitor mishaps include heart trouble and ankle fractures.

Trails suitable for day hikes below the rim include **Queen's Garden** (1.7 miles round-trip), **Navajo Loop** (1.5 miles round-trip), **Peekaboo Loop** (4.8 or 5.5 miles round-trip), or **Fairyland Loop** (8 miles round-trip). Day hikes available above the rim include the **Rim Trail** (up to 11 miles round-trip) along Bryce Amphitheater, and the **Bristlecone Loop** (one-mile round-trip) near Rainbow Point. Overnight hikes, which require permits, include the **Under-the-Rim Trail** (up to 23 miles one way) and **Riggs Spring Loop Trail** (8.8 miles round-trip). Check at the visitor center for permit availability. Horseback rides through Bryce Amphitheater are available spring through fall; inquire at Bryce Canyon Lodge.

Midsummer monsoons bring afternoon thunderstorms and intense, localized rain. Lightning hits without warning, and narrow canyons flood in a flash, so be alert and take appropriate action. In winter, heavy snows may close trails. However, be not discouraged; winter is a wonder at Bryce. When snow falls (the annual average is 95 inches), winter-starved desert dwellers come from afar to snowshoe and cross-country ski the ungroomed trails of Bryce. The visitor center loans a few snowshoes free of charge; rental ski equipment and groomed trails are available outside the park. Winter temperatures often fall below zero, and hypothermia (lowered body temperature) can be a serious problem for the unprepared; dress warmly. In spring, melting snows make muddy, slippery trails. Nevertheless, a hike below the rim into the world of Technicolor hoodoos, thin stone bridges, open windows, and sweeping arches is worth it all.

PAGE 28/29: Bryce Amphitheater seen through a tunnel on the Peekaboo Loop Trail. PHOTO © GARY LADD

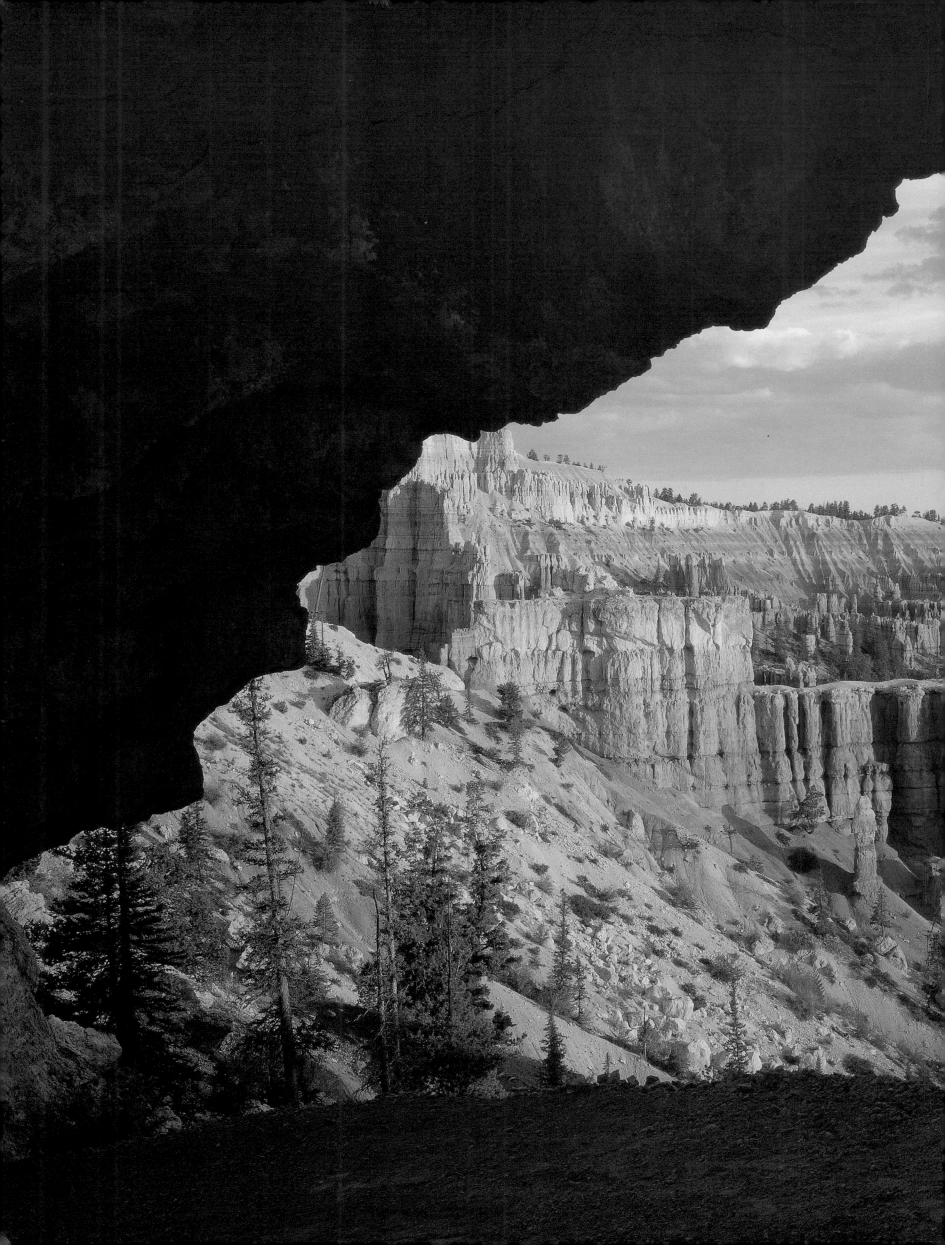

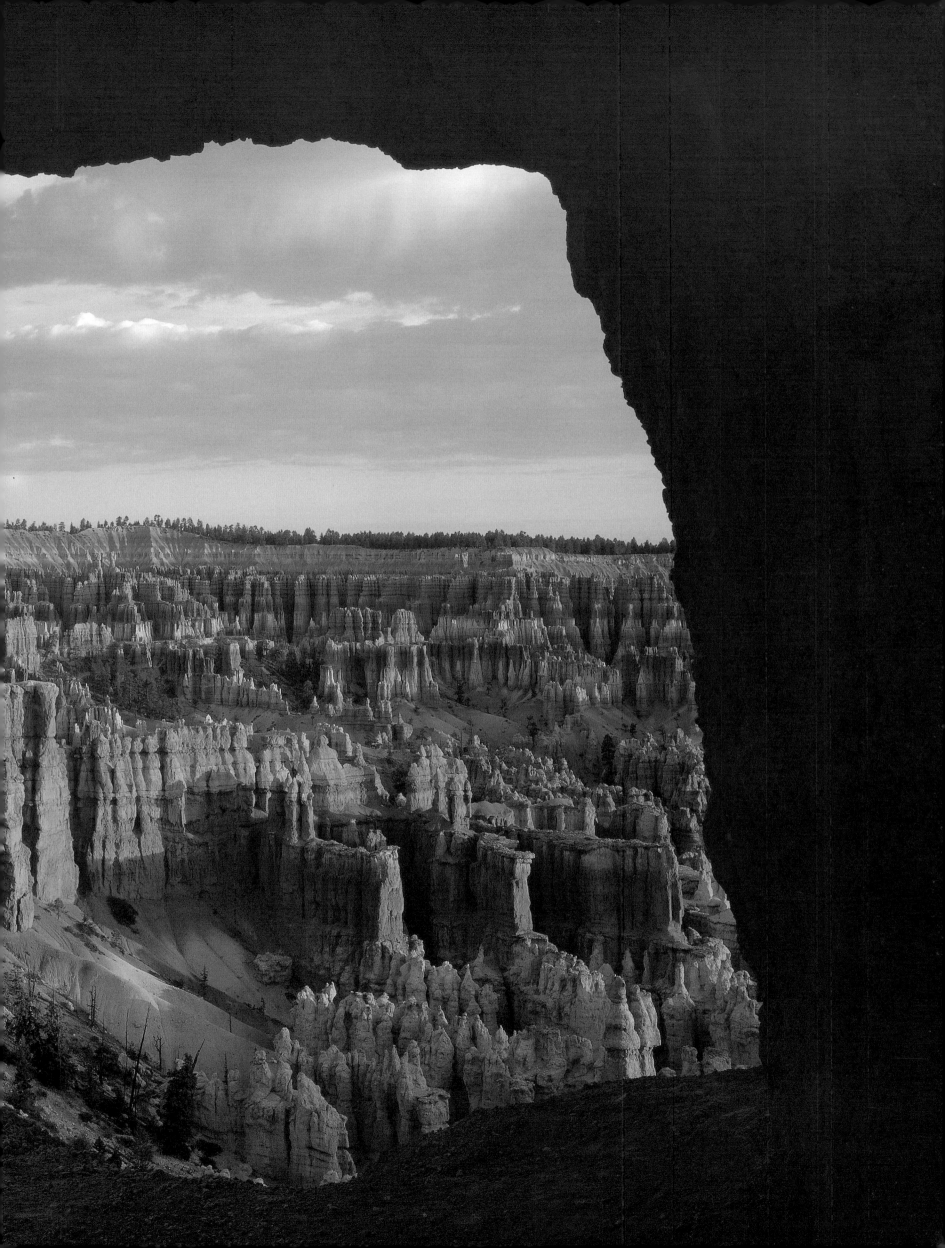

HUMAN HISTORY

Until now, there has been little indication that prehistoric peoples dwelled in Bryce or on the 9,000-foot-high Paunsaugunt Plateau. Fierce winters and short summers make life difficult at high altitudes. But recently, archaeologists have found surprising evidence showing this area has been an enduring home to many, beginning with the first peoples to set foot in Utah about 11,000 years ago.

Spear points found in mammoth kill sites west of Bryce show that a people we call Paleo-Indian hunted now-extinct megafauna. As immense animals declined and disappeared, this culture transformed to fit the changed environment, becoming around 8,000 years ago, a tradition we call Archaic. Sites from this time found in and near Bryce reveal that these people spent winters in the desert and summers atop highlands gathering pinyon nuts, sego lily roots, prairie dogs, rabbits, and mule deer—a pattern followed by ensuing cultures.

Recently discovered pithouse villages, attributed to the Fremont culture, reveal long-term, seasonal plateau occupation beginning around 1,500 years ago. The Fremont, long considered a remote and unusual variation of Anasazi culture, are unfolding as a marvelously unique culture in their own right. Archaeologists now speculate the Fremont spoke their own language, lived a different lifestyle, and held a world view distinct from neighboring Anasazi. For hundreds of summers, the Fremont returned to gather cattail, pinyon, and mule deer, while also maintaining minimal crops along stream courses. Below the plateau, among the Paria River's canyons and mesas, people of the Anasazi tradition constructed year-round farming communities of stone-walled homes and visited the plateau infrequently. Most of the bold rock art seen covering redrock walls throughout this area—usually ascribed to the Anasazi—is actually Fremont.

After the Anasazi and Fremont left about 700 years ago, Numic-speaking groups entering from the west settled comfortably into this landscape. These families, later called *Paiutes*, owned and depended on springs in and around Bryce, like

Piki-pa below Yovimpa Point, which may be what we know today as Riggs Spring. Living in small groups, moving seasonally, gathering and hunting the plateau's wild life, and maintaining small gardens, the Paiute may have been the people best suited to this environment.

In 1847, when the Mormon culture arrived, the Territory was already quite full, supporting thousands of Ute, Goshute, Navajo, and Paiute

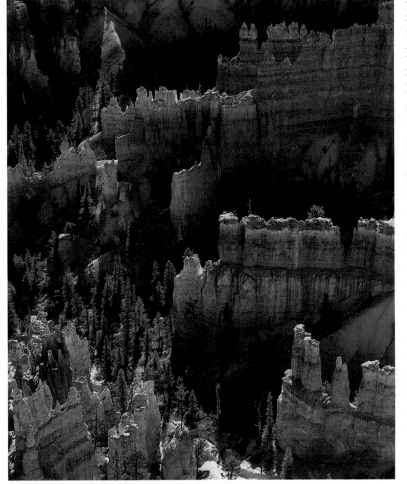

people. During the 1860s, as Mormon expansion outpaced available natural resources, inevitable conflicts followed. Near Bryce, the existing settlements—Glendale, Kanab, and Johnson—had to be abandoned during the "Indian Troubles."

In 1866, 65 men on a Mormon Militia reconnaissance led by Captain James Andrus entered the unknown country east of the plateau searching for Colorado River crossings used by the Navajo to raid Mormon settlements. The party never saw the river, but they were the first documented European-Americans to see Bryce as they passed on the slopes below. "Indians" attacked once, killing Elijah Averett Jr., who lies buried in a small

canyon east of Farview Point that now bears his name. After 1870, with Utah's Native peoples at all-time lows, Mormon pioneers filtered back to their evacuated homesites.

In 1869, John Wesley Powell and his intrepid band were the first to explore the Colorado River. Returning in 1872, Powell appointed the indefatigable Almon H. Thompson to survey the last unmapped region in what would become the United States. It took Thompson four years to map the rugged area from Bryce to the Dirty Devil River and from Boulder Mountain to the Grand Canyon. In doing so he discovered and named the Escalante River and became the first European-American we know of atop Bryce, as well as the Table Cliff and Kaiparowits Plateaus. Upon emerging from the wilds in 1875, Thompson met Mormon men scouting a townsite in Potato Valley. He suggested they name their town Escalante, after the Spanish explorer. In later years, Thompson helped form a small group whose aim was to increase geographical knowledge, they called it the National Geographic Society.

Settlement began "below Bryce," as locals say, with the founding of Escalante. That same year Ebenezer Bryce homesteaded along the Paria near a canyon draining the Pink Cliffs. In the five years Bryce and his wife Mary lived there, people began to refer to the wash as Bryce's Canyon. Over time, the name came to refer to what is now known as Bryce Canyon National Park.

Unlike the Native peoples before them, these pioneers, many from the eastern United States and northern Europe, depended upon sizable streams to irrigate farms. Thus, settlements appeared along rivers and suitable creeks draining the Paunsaugunt Plateau: Kanab Creek, Johnson Canyon, and the Paria River. But rivers and springs in this country ebb and flow with yearly precipitation. In dry years, springs wither and rivers run ankle deep; in wet years entire towns dissolve in devastating floods. Agriculture was more than a challenge along these inconstant rivers. Between 1875 and 1889, at least 20 towns sprang up along the Paunsaugunt's drainages, but only six survive.

ABOVE: Ponderosa pine, Douglas fir, and pinnacles below Inspiration Point. PHOTO © CHARLES CRAMER

Then there was Tropic.

In 1891, pioneers weary of the Paria River's unstable course, decided to create their own river flowing through higher, more open ground. To this end, they built 25 miles of ditches, dams, and diversions to redirect water from the north-flowing East Fork of the Sevier River west of Bryce into the Tropic Valley east of Bryce. This water flows from Tropic Reservoir past Ruby's Inn to the rim in Bryce Canyon National Park. It then pours over "the dump," tumbling down Water Canyon like a mountain stream, crosses under Highway 12 at the Mossy Cave Trailhead, and into Tropic's fields. After irrigating, the water enters the south-flowing Paria River.

From 1875 to 1923, Bryce was used intensively by settlers living "under the dump" for grazing and timber. As early as 1890, Utah residents recognized the tremendous ecosystem degradation caused by these activities. In 1899, in an effort to curb unchecked use, national forests began to appear in Utah.

In 1915, a U.S. Forest Service Supervisor named J. W. Humphrey was transferred to the Sevier Forest (now the Dixie National Forest surrounding Bryce Canyon). Humphrey thought he knew what there was to know of fantastic desert formations having transferred from the spectacular scenery of Moab, Utah, until a local ranger took him to the Bryce Canyon rim. He said, "You can perhaps imagine my surprise at the indescribable beauty that greeted us, and it was sundown before I could be dragged from the canyon view. You may be sure that I went back the next morning to see the canyon once more, and to plan in my mind how this attraction could be made accessible to the public."

Due in most part to Humphrey's enthusiasm and work, the State of Utah proposed Bryce Canyon as a national park in 1919, the same year Zion and Grand Canyon became national parks. Four years later, President Warren G. Harding declared Bryce a national monument. But Utah still wanted Bryce to be a national park, and after years of convoluted politics, Bryce Canyon was so designated in 1928. In the interim, U.S. Forest Service administered Bryce. The first permanent National Park Service ranger, Maurice Cope, was appointed in 1933.

At the same time, visitor accomodations began to appear on the rim. In 1920, Ruby and Minnie Syrett, nearby homesteaders, provided food and lodging near Sunset Point until 1923, when they sold their holdings to Union Pacific railroad. The Syretts then opened a modest lodge, now called Ruby's Inn, on the route to Bryce. Meanwhile, the Union Pacific hired a young architect to design lodges in the Rustic Style for Zion and Bryce. Gilbert Stanley Underwood designed such grand, natural structures that he not only set the style for national parks, but went on to great fame, later designing lodges for Cedar Breaks, Grand Canyon's North Rim, and Yosemite.

In the 1930s the scenic drive was extended from its terminus at Sunset Point first to Paria View and then Rainbow Point. From 1933 to 1942, Company 962 of the Civilian Conservation Corps (also known as the CCC) built numerous park facilities, many of which still stand: the log comfort station at Sunset Point, the exhibit structure at Rainbow Point, and the Under-The-Rim, Fairyland, and Bristlecone Trails. The National Park Service structures we use today weren't in place until the 1960s.

History doesn't end; it is being made. Mormon communities still irrigate from the Tropic Ditch; floods still scour Paria Canyon; Paiute voices linger on the land in today's Paiute Tribes, and as their words fall from our lips: Kaiparowits, Paunsaugunt, Yovimpa, Kanab, Panguitch.

The hoodoos of Bryce have watched silently as human cultures passed on the desert below and the plateau above. One after another, peoples arrived in this place, stayed as long as the land and other cultures allowed, then moved on, bound for the next stop on their journeys. Just as we are now.

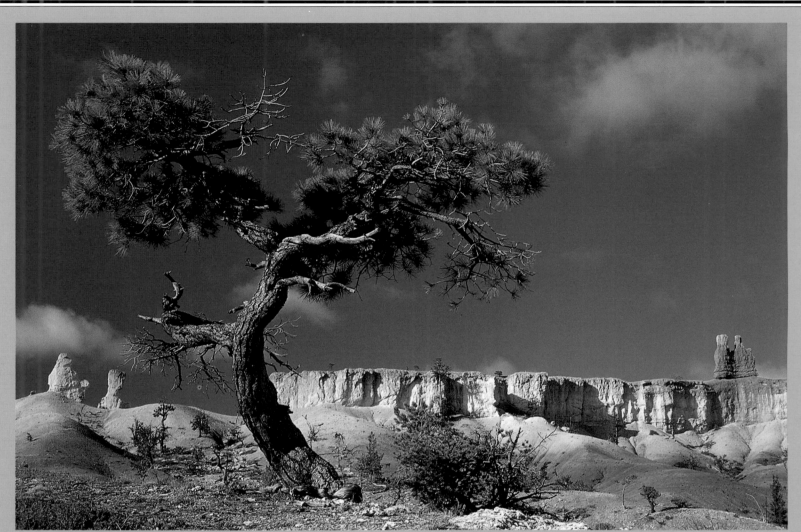

Contorted ponderosa pine below the rim.

PHOTO © CAROL POLICH

LIFE BELOW THE RIM

In contrast to the cool, sturdy rim forests, the world below the rim is strange and amazing. Ponderosa pines contort their tall elegance into humpbacked dwarfs, bared tree roots snake along paths like tentacles, and delicate columbines burst from rock like shooting stars falling through a lavender night.

Environments below the rim are perfect for those plants that meet demanding criteria. Low precipitation, intense heat and cold, limited nutrients, loose footing, constant erosion, high winds, freeze-thaw cycles, and a dearth of soil and its microorganisms give rise to a specialized community of life. Successful flora tends to be hardy, tiny, perennial, slow growing, and often woody. In addition, minute changes in steepness, slope direction, exposure, soil type, and water availability produce innumerable **microenvironments** which entice plants that find these nooks to their liking.

Curious **bristlecone pines** (*Pinus ponderosa*) stand like sentries on barren, exposed ridges and exemplify what it takes to succeed in the below-the-rim club. Bristlecones are extremely slow growing and outrageously perennial—one individual in Bryce is at least 1,600 years old. The bristlecone's dense and twisted wood resists thousands of scalding summers and frigid winters; growth occurs when circumstances meet its needs. Even the tiniest plants nudging from the pebbled hillside, like the tiny purple-flowered **beard-tongue**

dwarf (*Penstemon caespitosus*), the holly-leaved **Fremont barberry** (*Mahonia fremontii*), and ivory-capsuled **twinpod** (*Physaria chambersii*), live bristlecone lives.

The rapid erosion of amphitheater basins often dislodges or buries small plants. Roots, like those of the ponderosa pine, sprawl above ground, impairing the plant's ability to absorb nutrients and water. But life below the rim is adapted for such challenges.

When these big trees do fall, the desert's lack of moisture and decomposers leaves them as smooth and untouched as bleached bone. Fallen trees and dead plants rarely rot, so Bryce slopes gain little soil. Without soil, few nutrients reach growing plants. These interwoven environmental factors sow a lean, thrifty, and complex garden below the Bryce rim.

This lower world is also the domain of heat-adapted animals like **tree** and **side-blotched lizards** (*Urosaurus ornatus* and *Uta stansburiana*), **striped whipsnakes** (*Masticophis taeniatus*) and **wandering garter snakes** (*Thamnophis elegans vagrans*). Early summer evenings spent near rain-swollen pools and dripping springs erupt with serenades of **Woodhouse's** and **spadefoot toads** (*Bufo woodhousei* and *Scaphiopus intermontanus*). **Coyotes** (*Canis latrans*) shoot furtive glances while **silver-haired** and **big-brown bats** (*Lasionycteris noctivagans* and *Eptesicus fuscus*) hunt airborne insects in the warm night. This exclusive community designed by select environments and populated by preferred inhabitants beats only in the warm chambers of the heart of Bryce.

OPPOSITE: Weatherbeaten bristlecone pine below the rim. PHOTO © PAT O'HARA

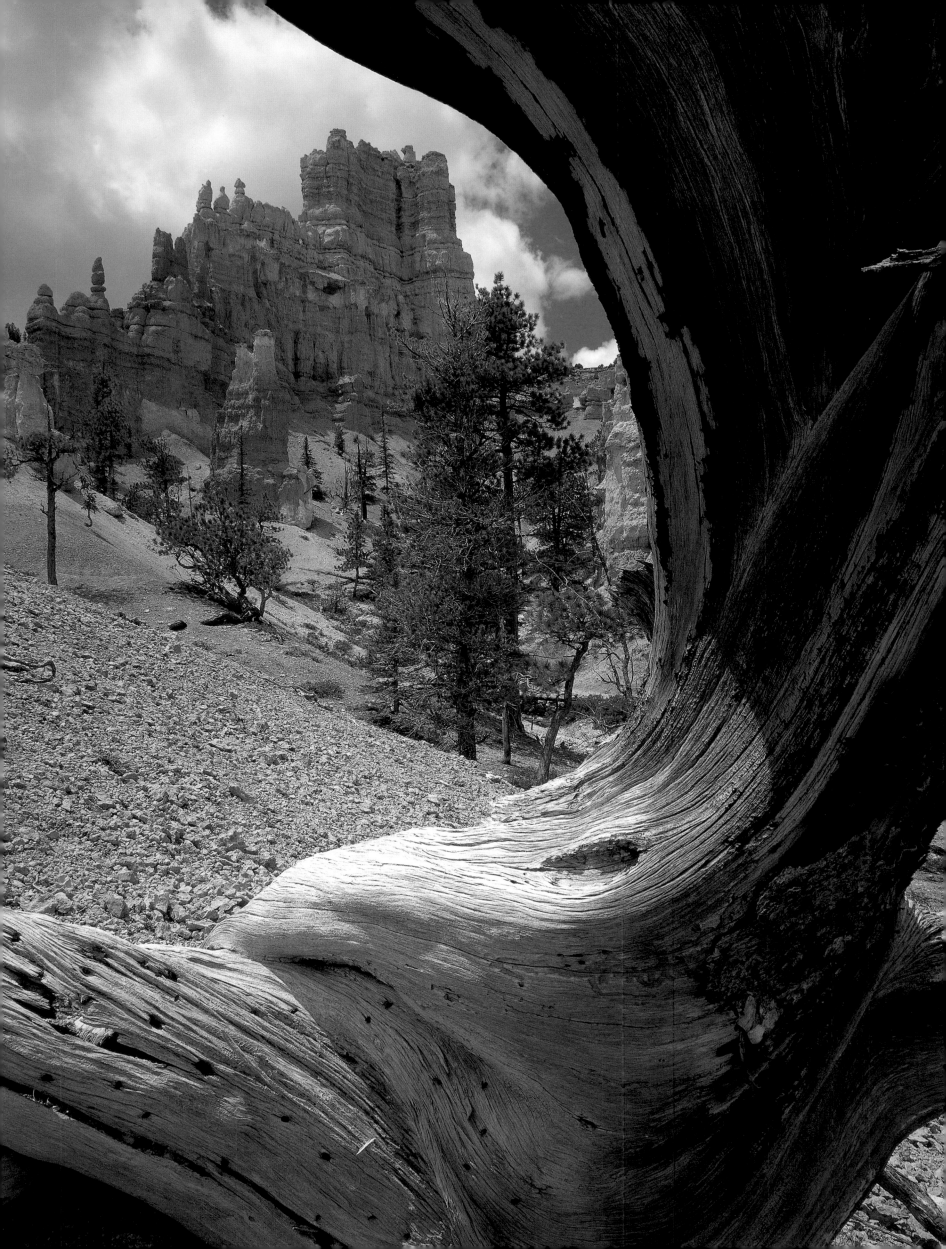

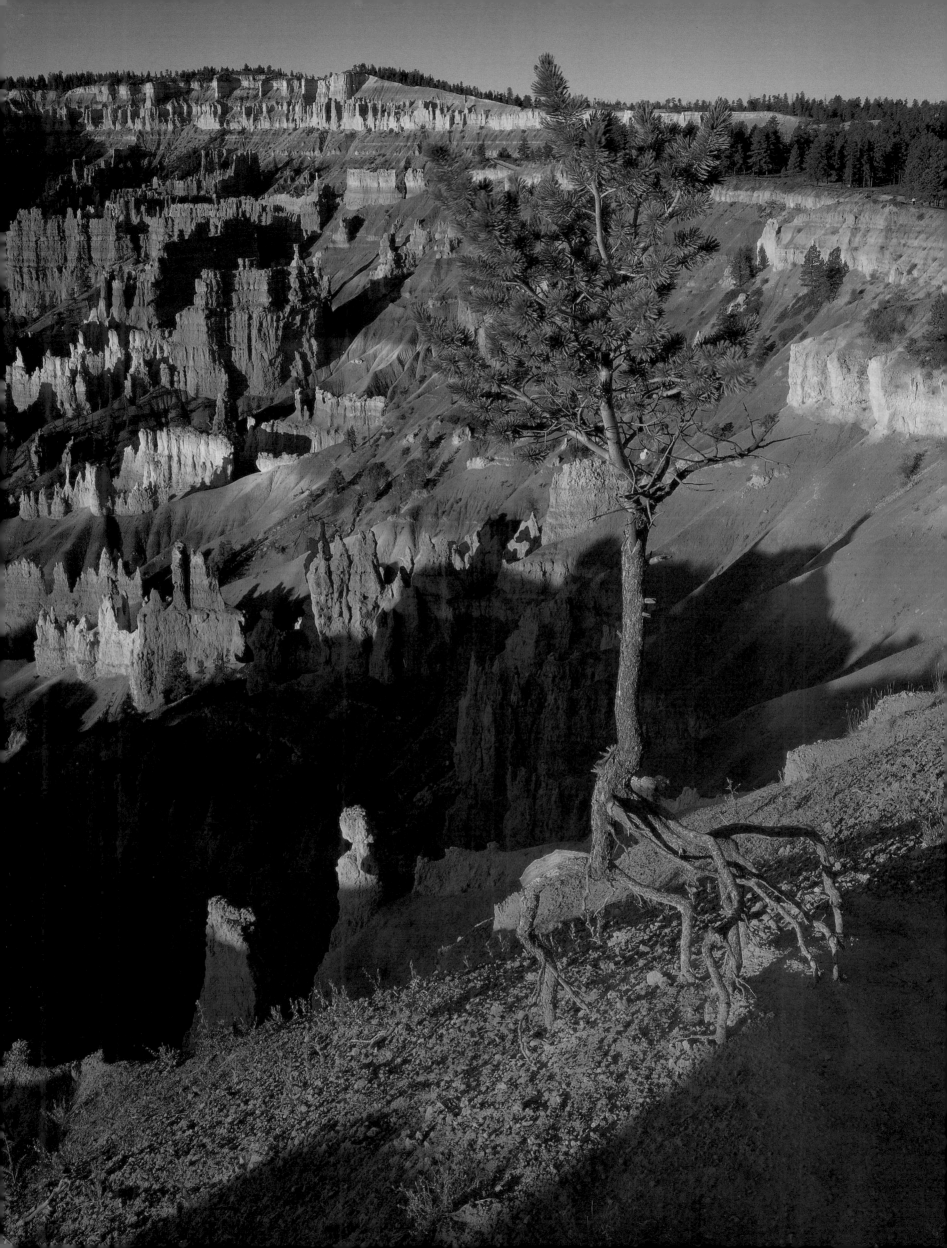

BEHIND THE RIM:

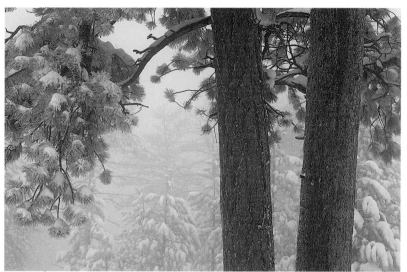

Ponderosa pines in deep winter snow and fog. PHOTO © PAT O'HARA

I stand in an open flat shading my eyes from the sun as an eagle soars overhead—golden or bald? I strain for some diagnostic signature, a flash of white, a metallic glint, and expect the eagle to flap away just before I ascertain its identity. But it lingers, effortlessly hanging on the breeze without beating a wing. The bird, black as coal, circles so slowly it seems it will fall from the sky. Hands on hips I resume my walk, keeping an eye on the mystery. Then it comes, I wheel around as the answer rushes in: the feathers splayed like giant fingers, the wings so long, so black—it's *not* an eagle. I whoop and holler and jump—my first California condor!

Until their reintroduction in 1996 along the Vermilion Cliffs just 45 miles south of Bryce, I hadn't much need for condor-identification skills. But now condors, with their nine-foot wingspans, occasionally swoop along the Bryce rim and roost for an evening among hoodoos. Able to fly 150 miles in a day, at elevations as high as 15,000 feet, they have been spotted as far away as Flaming Gorge National Recreation Area in Wyoming, Grand Canyon National Park in Arizona, and Mesa Verde National Park in Colorado. But before reintroduction, California condors no longer existed outside zoos.

In 1987, when only 27 remained in the world, the last free-flying California condor was brought into a captive breeding program. Many pronounced the condor doomed, its million-year reign floating above the American West over. But due to a successful program, by 2000 over 160 condors existed, over 50 in the wild.

Many people think condors are a remnant from the age of mastodons. They wonder if it's important to save a species that can't "make it on its own." In reality, large animals—bighorn sheep, mountain lions, bears, humans—are all prehisotric holdovers. It is not that condors are obsolete, but that humans changed their environment so completely they can no longer survive in what's left.

California condors are actually *wilderness* holdovers, as are we all. In the 1800s, western North America was carpeted with lush native grasses supporting immense herds of elk, bighorn, pronghorn, and deer. One engineer reported stopping his train for two hours while a herd of pronghorn ran across the tracks. Large numbers of mountain lion, lynx, bobcat, and bear culled herbivore populations, and condors, at the top of the food chain, feasted on them all. In this wondrous diversity and enormous bounty lay dynamic equilibrium, a type of natural shock absorber. But, as we know, ailing and missing parts have weakened such natural systems. Scientists estimate that the combined populations of bighorn, elk, and pronghorn total less than 1 percent of their former numbers. Reintroduced condors won't have much to eat; humans will supplement their diets with beef and mutton.

At Bryce, wild turkeys nibble along forest edges, peregrine falcons rocket over cliffs, and prairie dogs tussle in golden meadows. Just outside the park, elegant pronghorn graze in open grasslands, elk bugle autumn yearnings, and bighorn sheep bound from canyon walls. But a peek behind the rim, behind the veil reveals a surprise: all of these have been reintroduced.

Bighorn sheep, the most common animal remains found in Colorado Plateau archaeological sites, once nurtured thousands of people. But domestic sheep diseases introduced in the late 1800s combined with overhunting, lead to their local extinction by the 1930s. Native elk were hunted out by 1911, and Rocky Mountain elk were introduced. Peregrine falcons disappeared throughout western North America due to the effects of pesticides.

Animal checklists indicate that mountain lions stalk in soundless nights and black bears root in heavy forests, but no one knows how many actually exist. Erased from the checklist are wolves, grizzlies, and innumerable species we never knew. In their absence, foreign species thrive: ring-necked pheasants, starlings, house sparrows, red brome, tumbleweed, cows.

When the National Park Service was created in 1916, its purpose was to preserve the nation's scenic wonders. Parks were thought of as amenities and natural curiosities. But over time, they have become essential preservers of habitat, species, ecosystems, recreational opportunities, and dwindling resources.

In 1923, foresighted people set Bryce Canyon aside as a national monument, sensing value not only for themselves but also for

OPPOSITE: Limber pine with precarious footing at the edge of Bryce Amphitheater. PHOTO © JOHN TELFORD

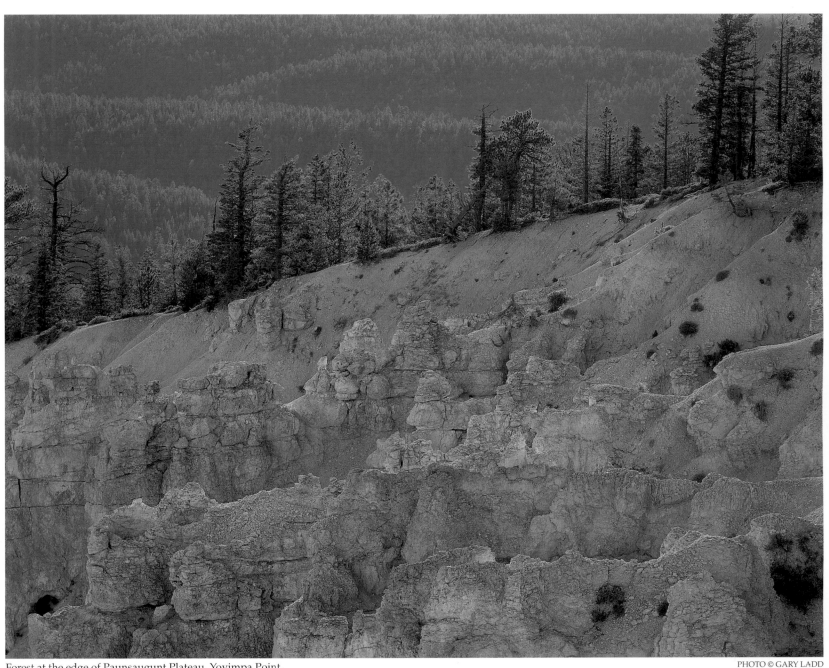

Forest at the edge of Paunsaugunt Plateau, Yovimpa Point.

"future generations." We are those future generations, and many more follow us. Nothing exists alone in the world—a condor, Bryce Canyon National Park, you, me—we are imbedded in a living matrix so much a part of us we don't see it. Our time asks us not only to pass on what was given us but also to repair the matrix and nurture the whole. It is time to see not only the beauty and wonder, but also the reality, behind the veil.

Without a wingbeat my condor has reached the top of its helixing thermal. These birds can see what's invisible to us—swirling columns of hot air rising from the land. Tapering to the top of one thermal, a condor then slides to the next, regains altitude, and glides on again, traveling for hours and as long as changing winds allow. Now it's only a dot against the azure sky, but I know it's there, and that comforts me.

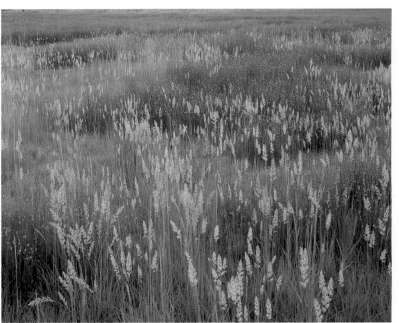

Summer meadow grasses.

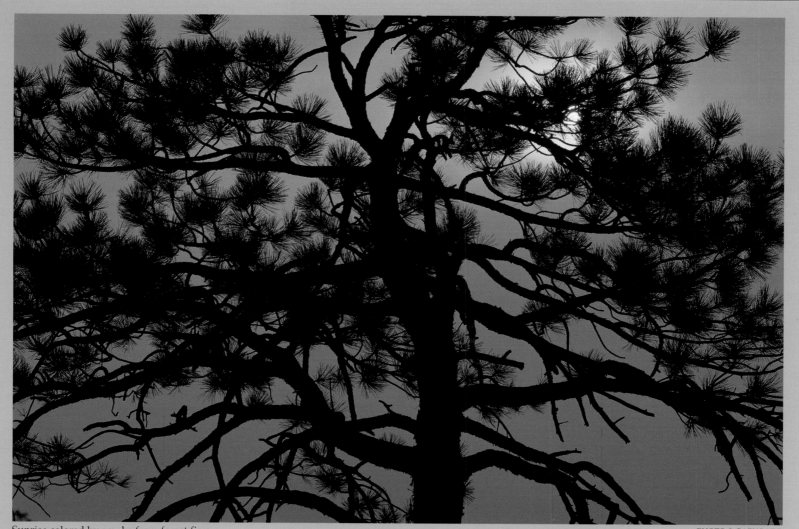

Sunrise colored by smoke from forest fires.

THE ROLE OF FIRE

If you are from a moister landscape, say Europe or the eastern United States, forest fires may be a rare and somewhat threatening event. When pioneers from wetter places reached this arid region in 1875, they thought so too. In this treeless land, where lumber from the Paunsaugunt Plateau's big trees built houses, wagons, and butter churns, settlers quickly began extinguishing natural fires. As early as 1899 national forests were designated near Bryce, and foresters, believing fire wasted trees, implemented even stronger suppression policies. What these new Westerners didn't know was that here, forests live by fire.

In damper climes, decomposers—bugs and bacteria—thrive. In the waterless desert decomposers barely exist, and so, as Henry David Thoreau said, "Nature invites fire to sweep her floors, for purification." Before settlement, lightning strikes regularly lit small, sprucing-up fires that traveled along the ground through Utah's then-abundant grass, smoldered through fallen logs, devoured lower tree limbs, and scarcely licked dense trunks. In Bryce, individual areas burned every three to seven years, gently keeping pace with accumulating wood.

Without fire's pruning, young pines sprout in thickets dense as dog's hair, eliminating light-loving aspens, and further crowding the forest.

In close company, diseases and parasites flourish, killing more trees and adding to the spiraling pyre. After 100 years of suppression, logs pile as if stacked for a giant fire, dead branches stick like brittle snowmen's arms low on tree trunks, and shrubs, dry as tumbleweed, pile thick and fine as tinder at the forest's feet. Now when a fire starts, it explodes in mounds of kindling, swings like a trapeze artist from low, dead branches into the forest's crown, ignites living trees like enormous wicks, and kills everything within reach. These catastrophic burns began only after natural fire ceased its customary summer walks through the forest.

In earlier days, settlers could drive a wagon pulled by a full team of horses through the open, grassy ponderosa forests of Bryce. Now, these same forests, too dense to walk through, clog with deadwood and await the next lightning strike.

In an effort to restore healthy, nonthreatening forests, the National Park Service hopes to begin a program of forest management that includes lighting prescribed burns and allowing natural fires—as long as they meet the correct prescription.

Perhaps one day, visitors will experience the open luxury of a more natural forest at Bryce. A forest where abundant aspen flicker like golden candles in an embracing wreath of pine, and where lightning stroking the afternoon is a welcome sight.

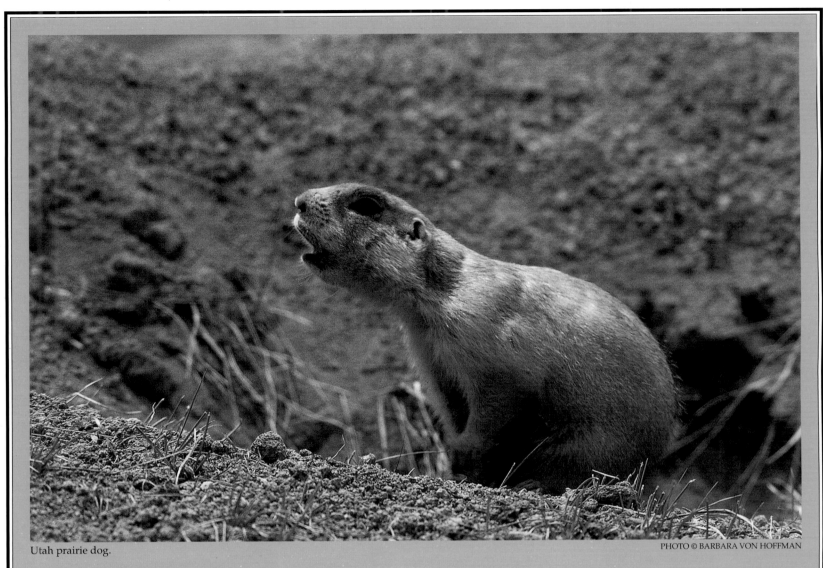

Utah prairie dog.

PRAIRIE DOGS

Prairie dogs dressed in meadow camouflage trundle through summer grass while others munch near burrows or stand vigil. Usually the color of golden wheat, Bryce prairie dogs (*Cynomys parvidens)* sport hand-painted black coats so that Dr. John Hoogland can identify individuals and chart every move these rare dogs (actually rodents) make. Bryce Canyon is the only national park in the world that harbors Utah prairie dog colonies. Although there are four other species in western North America, the Utah prairie dog, which lives only in southwestern Utah, is the rarest.

Hoogland, a wildlife biologist from the University of Maryland, has studied prairie dogs for 26 years, the last five from lanky wooden towers in Bryce. His research team arrives in March just as prairie dogs emerge from hibernation, and works until July when the dogs move underground to prepare for their eight-month winter nap. Researchers scribble notes as the prairie dogs mate in early spring, create grass-lined nests where entire families sleep, and communicate with a system of distinctive barks. The colony divides into territories; each inhabited by an adult male, three to four adult females, one to two yearlings, and several juveniles. Males often engage in spectacular brawls over turf and mates. In late spring, prairie dogs and their babies surface to the sun's warm encouragement.

There was a spring, however, around 1950, when prairie dogs no longer poked their heads from the cozy burrows of Bryce. More than 100 years of shooting and poisoning by ranchers and the ravages of an introduced disease—bubonic plague—left the Utah prairie dog near extinction. In 1910 an estimated five billion prairie dogs covered the west from Canada to Mexico; now they remain on only 2 percent of their former range. In the 1970s, a few Utah prairie dogs removed from colonies being destroyed by development were moved to Bryce and began Hoogland's study colony. Now this reintroduced colony bubbles with more than 300 dogs.

The few colonies at Bryce, although protected, are not immune. Bubonic plague, which arrived in America during the 1800s, quickly exterminates entire colonies, as happened at Bryce in 1995. As prairie dog populations dwindle, plague becomes more dangerous; one outbreak could wipe out this entire species. Dr. Hoogland, like a prairie dog on the alert, watches over Bryce's rare colony. With hope, his research will provide ways to better focus our efforts to save the fascinating species.

The park service requests that you drive carefully, stay out of colonies, and resist the temptation to feed, or pursue prairie dogs for photographs. These precautions are necessary for the safety of both prairie dogs and humans, since either can contract bubonic plague.

OPPOSITE: Morning sun and ponderosa pines, mid-winter on the Paunsaugunt Plateau. PHOTO © FRED HIRSCHMANN

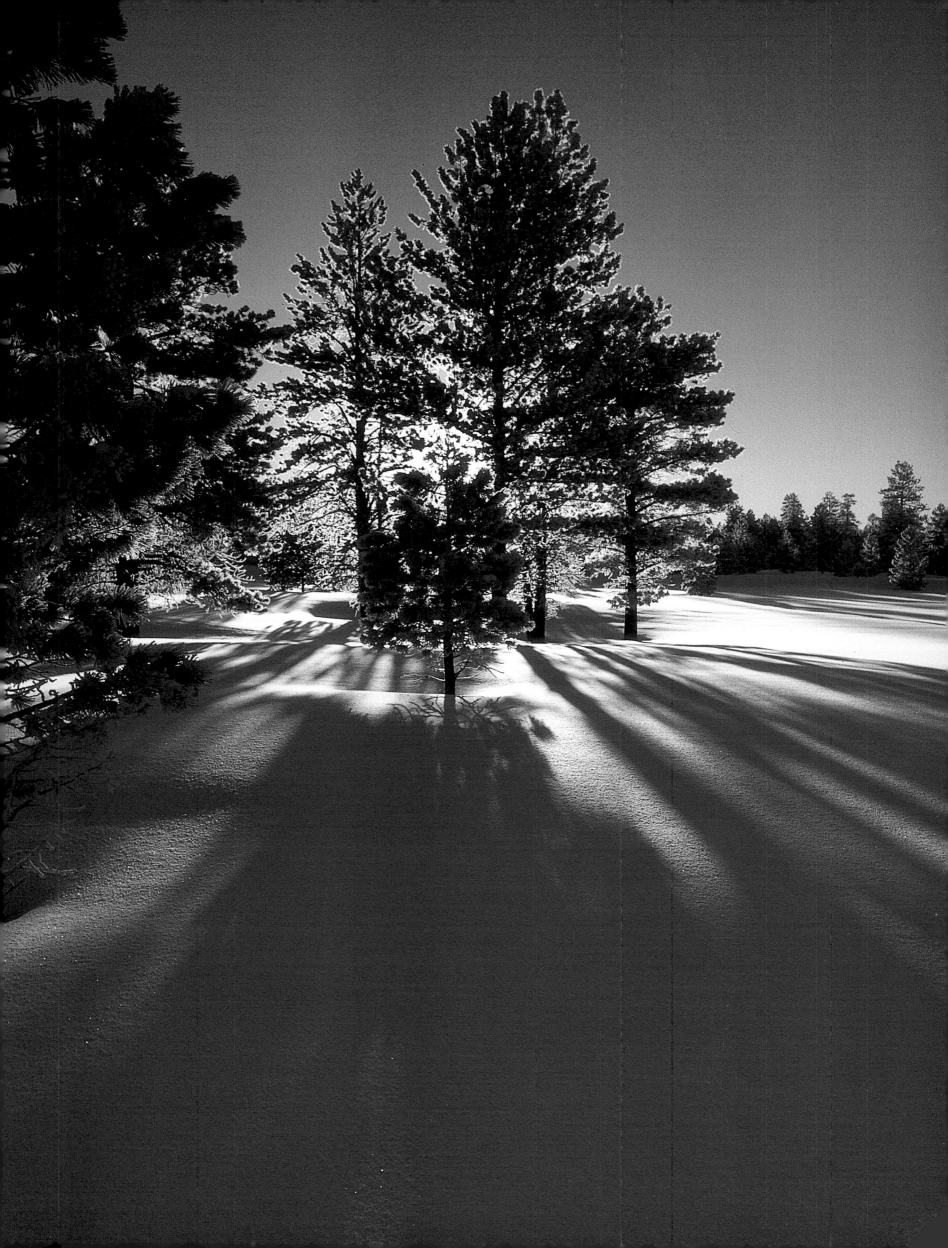

BIRDS

Stellers jay.
PHOTO © TOM & PAT LEESON

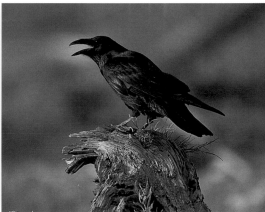

Raven.
PHOTO © KENNAN WARD

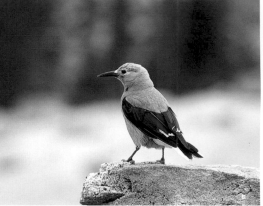

Clarks nutcracker.
PHOTO © KENNAN WARD

If there is one thing Bryce doesn't lack, it is birds. In high-elevation spruce-fir forests like those near Yovimpa Point, heavy-bodied **blue grouse** (*Dendragapus obscurus*) peck the forest floor for insects and seeds to the ethereal music of a **hermit thrush** (*Catharus guttatus*) overhead.

Near Sunset Point, lower-elevation ponderosa forests hide **wild turkeys** (*Meleagris gallopavo*) as they strut and gobble in the early morning. At night, **great-horned owls** (*Bubo virginianus*) call and answer, their long *hooos* drifting over the canyon's edge. Picnickers quickly learn to protect their lunches from the ponderosa forest's bold robbers—the royal blue, black-crested **Stellers jay** (*Cyanocitta stelleri*) and the gray-bodied, black-winged **Clarks nutcracker** (*Nucifraga columbiana*). Two different bluebird species flit between ponderosas and perch on conspicuous branches, the sky-blue **mountain bluebird** (*Sialia currucoides*) and the red-chested **western bluebird** (*Sialia mexicana*).

On the rim during summer, it's hard to miss the aerobatics of **white-throated swifts** (*Aeronautes saxatalis*) and **violet-green swallows** (*Tachycineta thalassina*) as they whiz overhead, hurtling after flying insects. To distinguish them, note that swifts have black-and-white underparts, while swallows are pure white below. It's also impossible to overlook the antics of **common ravens** (*Corvus corax*), the large, jet-black birds soaring and chattering between towering hoodoos. Visitors walking narrow canyons below the rim are treated to reverberating and amplified squawks, caws, croaks, and chuckles from these unseen speakers.

One of the most fascinating birds visitors might see at Bryce is also one of the world's rarest: the **California condor** (*Gymnogyps californianus*). Condors, with their nine-foot wingspan should not be confused with ravens with their four-foot wing-span, although both are black. As recently as 1987, California condors no longer existed in the wild anywhere in the world. But in 1996, condors raised in captive-breeding programs were set free along the Vermilion Cliffs just 50 miles south of Bryce. Ranging as far north as Flaming Gorge, Wyoming, condors are sometimes seen on the Bryce rim. The condors wear large numbered wing-tags and radio-transmitters so researchers can follow their movements. If you see a condor, report it and its wing-tag number at the visitor center. Although condors seem unafraid, do not approach or feed them. Allowing them to become accustomed to people will be the death of them.

Condors, once more widespread, still hang by a delicate thread. We will have to work to ensure other birds that seem common to us now don't become the condors of the future.

Great-horned owl.
PHOTO © JEFF GNASS

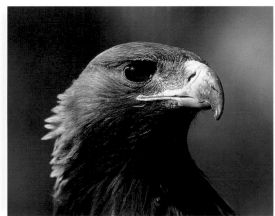

Golden eagle.
PHOTO © KENNAN WARD

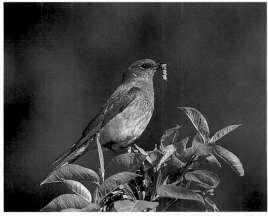

Mountain bluebird.
PHOTO © TOM & PAT LEESON

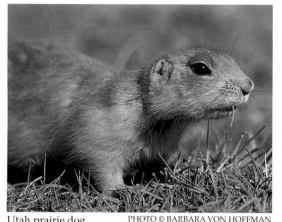

Utah prairie dog. PHOTO © BARBARA VON HOFFMAN

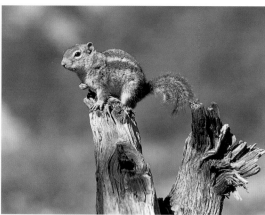

Golden-mantled ground squirrel. © RANDI HIRSCHMANN

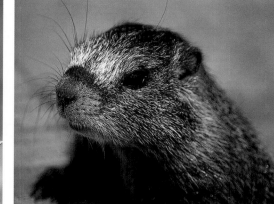

Yellow-bellied marmot. PHOTO © CAROL POLICH

Upon arrival at the rim, a greeting committee of **Uinta chipmunks** (*Eutamius umbrinus*) and **golden-mantled ground squirrels** (*Spermophilus lateralis*) appears instantly. The two look very similar; both have white sidestripes bordered by black along their reddish bodies. But the chipmunk also has an eye stripe, while ground squirrels don't. Both forage along the ground, stuffing their cheeks with seeds and nuts that they bury in small caches. Trees sprout from unused caches, replenishing forests. Chipmunks and ground squirrels eat manzanita berries, insects, and potato chips, cookies, crackers, even discarded food wrappers. No one knows how many animals sicken and die from this unnatural diet. Please, don't feed.

Endangered **Utah prairie dogs** (*Cynomys parvidens*) colonize forest openings and are often seen standing along roadsides. These rare and fascinating prairie dogs live in "dog towns," large colonies of individual families.

Bryce is the only national park in the world that harbors Utah prairie dogs; please don't introduce nonnative foods. Since, like most rodents, prairie dogs are excellent carriers of bubonic plague, don't walk into colonies or pursue dogs for photographs.

Another colony-dweller at Bryce is the secretive **yellow-bellied marmot** (*Marmota flaviventris)*, most often seen near the scenic drive's end. Marmots, reddish-brown with yellow-haired bellies and blunt-nosed faces, spend the short summer eating, preparing for an eight-month hibernation. When sensing danger, a lookout gives a sharp *pik!* and all marmots within hearing disappear underground.

Mule deer (*Odocoileus hemionus*) thrive on the Paunsaugunt Plateau. The large herd summers near Bryce, travels through Grand Staircase–Escalante National Monument in fall, and winters in less-snowy Arizona.

Interesting too, are the many species that should be here, but aren't. **Wolverines** (*Gulo gulo*) were gone by 1897, **grizzlies** (*Ursus arctos*) have been extinct in the park since 1916, and the park's last **gray wolf** (*Canis lupus*) was killed in 1928. **Pronghorn** (*Antilocapra americana*), which were extinct in the park area by 1936, have been reintroduced and can sometimes be seen on open flats outside the park. Prairie dogs were extirpated by 1950, but reintroduced in the 1970s.

At 35,835 acres, Bryce Canyon National Park is too small to provide adequate habitat for animals that require large ranges or that depend on resources outside the park. Thus, **mountain lion** (*Felis concolor*) and **black bear** (*Ursus americanus*) are rarely seen. Even large parks are losing species as development encroaches on their boundaries, consuming lands formerly used by big animals.

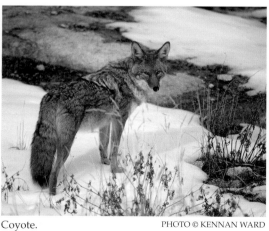

Coyote. PHOTO © KENNAN WARD

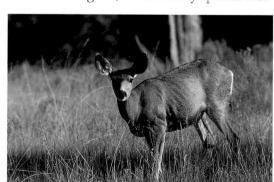

Mule deer. PHOTO © FRED HIRSCHMANN

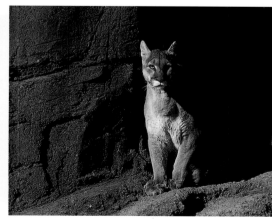

Mountain lion. PHOTO © KENNAN WARD

TREES

Douglas fir. PHOTO © JEFF D. NICHOLAS

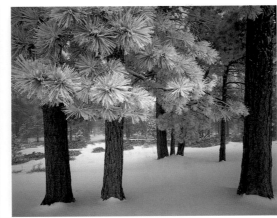
Ponderosa pine. PHOTO © JACK DYKINGA

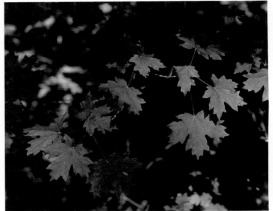
Bigtooth maple. PHOTO © FRED HIRSCHMANN

Approaching Bryce it's hard to imagine redrock formations spilling from a rim of cool, green forests. However, Bryce, in its high-altitude fastness, actually contains three remarkably different pine forests, each distinguishable by its trees.

Below the rim, at elevations ranging from 6,500 to 6,800 feet, annual rainfall averages 13 inches and **pinyon-juniper woodlands** predominate. **Pinyon** (*Pinus edulis*), with squat cones and needles bunched in twos, is known for its delectable pinenuts. These seeds contain 3,000 calories per pound and were a staple of native peoples and a delicacy today. Another plant essential to early peoples, **Utah juniper** (*Juniperus osteosperma*) is easily recognizable by its gray-rust shredded bark and cones like dusky blue beads.

Above the rim, where precipitation reaches 20 inches per year and elevations range from 6,800 to 8,500 feet, the **ponderosa pine forest** thrives. Tall, stately **ponderosa** (*Pinus ponderosa*), with their cider-colored bark and five- to ten-inch needles, dominate from the visitor center to near Farview Point. Burgundy-stemmed **manzanita** (*Arctostaphylos patula*) and shrublike **common juniper** (*Juniperus communis*) intermingle beneath the trees. Silver-barked **limber pine's** (*Pinus flexilis*) two-inch needles cluster in groups of five, giving branches a bushy look.

After open ponderosa forests and treeless meadows, visitors will notice the forest thicken just as the scenic drive begins its long climb toward the plateau's highpoint at Yovimpa. This stretch ranges from 8,500 to 9,100 feet, averages 25 inches of annual precipitation, and supports the **fir-spruce-aspen forest**. **White fir** (*Abies concolor*) and **Douglas fir** (*Pseudosuga menziesii*) predominate. Elegant **blue spruce** (*Picea pungens*) gather along ravines in a blue-green haze, and shimmering glades of fall **aspen** (*Populus tremuloides*) burst in yellow riots from forest openings. White fir, tall and gray-barked, holds single, flattened needles and auburn cones upright on its stems, while Blue spruce needles feel square when rolled between fingers. Douglas fir, not a true fir, holds drooping branches and cones that sprout "mouse tails" between their papery scales.

Bristlecone pines (*Pinus longaeva*), with twisted silver bark and branches resembling bottlebrushes, traditionally top high ridges and grow to ripe ages; one tree still living near Yovimpa germinated around BC 400. However, bristlecones also populate inner canyon slopes, showing that trees will ignore elevation and grow anywhere environmental factors create suitable conditions.

Although hoodoos often steal the show at Bryce, don't forget to stop and smell the ponderosas.

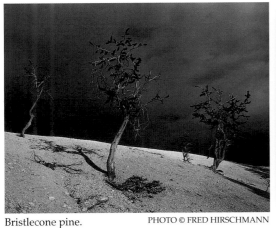
Bristlecone pine. PHOTO © FRED HIRSCHMANN

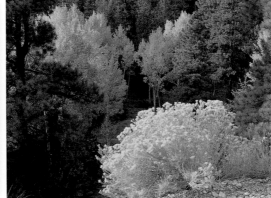
Aspens (in background). PHOTO © FRED HIRSCHMANN

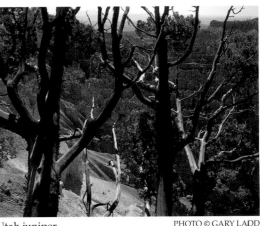
Utah juniper. PHOTO © GARY LADD

Showy stoneseed. PHOTO © LARRY ULRICH

Arrowleaf balsamroot. PHOTO © LARRY ULRICH

Bronze evening primrose. PHOTO © ROBERT HILDEBRAND

The wildflower season at Bryce peaks in late June and early July when high-country meadows and forests green from their winter watering. At 8,000- to 9,000-foot elevations, the Bryce growing season is short, lasting the few months between snowmelt and snowfall. Soil moisture is the most critical factor for wildflowers; dry seasons produce few flowers.

Below the rim, most plants are diminutive, stout, thick-skinned perennials able to survive parched summers and teeth-chattering winters. Nevertheless, even on these barren slopes, spring flowers, like the delicate lavender **rock columbine** (*Aquilegia scorulorum*) bloom. Columbines usually prefer cool, moist nooks, but this species seeks hot slopes and spring runoff. On dry soils, miniature white **cryptantha** (*Cryptantha capitata*) flowers pop from foliage only inches tall. Nearby, **twinpod** (*Physaria chambersii*), a six-inch-tall plant with leaves like little green tongues holds pale yellow flowers and paper-thin pods on upright stems.

Probably the most conspicuous flowering plant at Bryce regardless of season or location is **greenleaf manzanita** (*Arctostaphylos patula*). These evergreen shrubs grow only as tall as the depth of last winter's insulating snow. In spring, choruses of petite pink flowers held by polished mahogany stems dance on the wind. During summer, green berries or *manzanitas* (Spanish for "little apples") replace pink flowers, and are eaten by ground squirrels, chipmunks, and birds. Early peoples also ate and used manzanita medicinally.

In summer, blues, yellows, and reds punctuate forests. Early mornings look along the rim for **bronze evening primrose** (*Oenothera howardii*) before they fade in the heat. Each lovely yellow flower blooms for only one night. Delicate **blue flax** (*Linum lewisii*) nod from long, slender stems, and **narrowleaf paintbrush** (*Castilleja linariifolia*) holds flowers like red-tipped brushes. But, look closer, these "flowers" are actually overgrown, red-dened bracts (small leaves around a flower's base) and leaves. The actual flower, tubular and light green, knifes from its bracts like a blade from its handle. Paintbrush is a semiparasite, sinking special roots to siphon nutrients from other plants.

Careful observers might find the Utah state flower standing boldly in the spruce forest. The beautiful, three-petaled, white **Sego lily** (*Calochortus nuttallii*) was cherished by native peoples and pioneers alike for its edible bulb.

Fall's approach is announced as round-topped bushes, like **rubber rabbitbrush** (*Chrysothamnus nauseosus*), fuzz with yellow flowers. A member of the sunflower family, rabbitbrush grows to three feet and keeps its dried flowers, now ivory, all year.

As glimmering aspen fade overhead, winter's replenishing snows begin, initiating another wildflower year at Bryce.

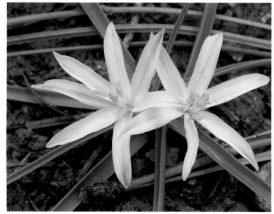

Star lily. PHOTO © LARRY ULRICH

Greenleaf manzanita. PHOTO © FRED HIRSCHMANN

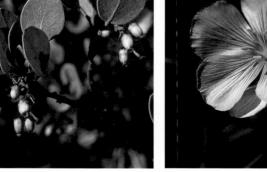

Blue flax. PHOTO © JEFF D. NICHOLAS

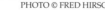

PAGE 44/45: Thors Hammer and glowing cliffs along Navajo Loop Trail. PHOTO © LARRY ULRICH

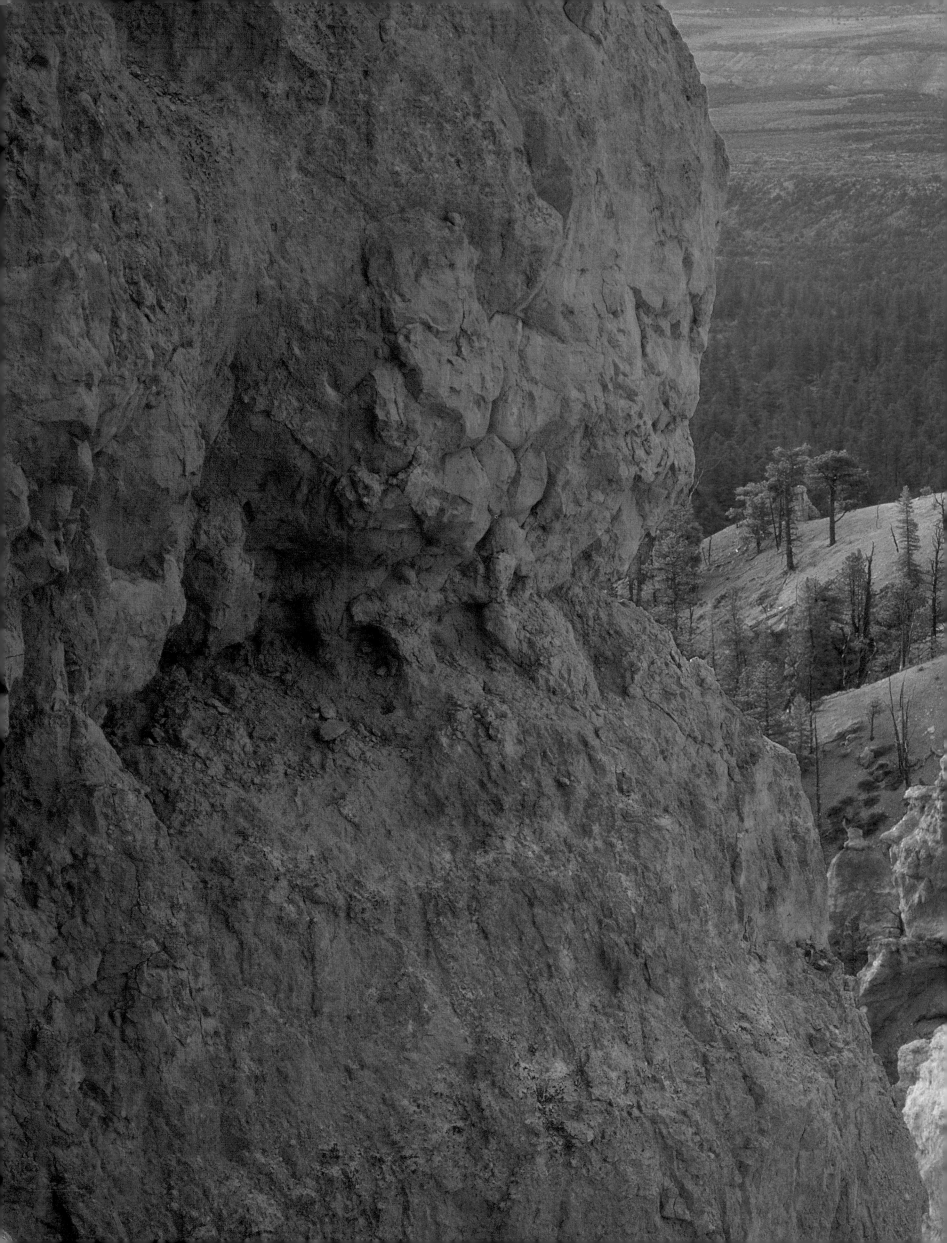

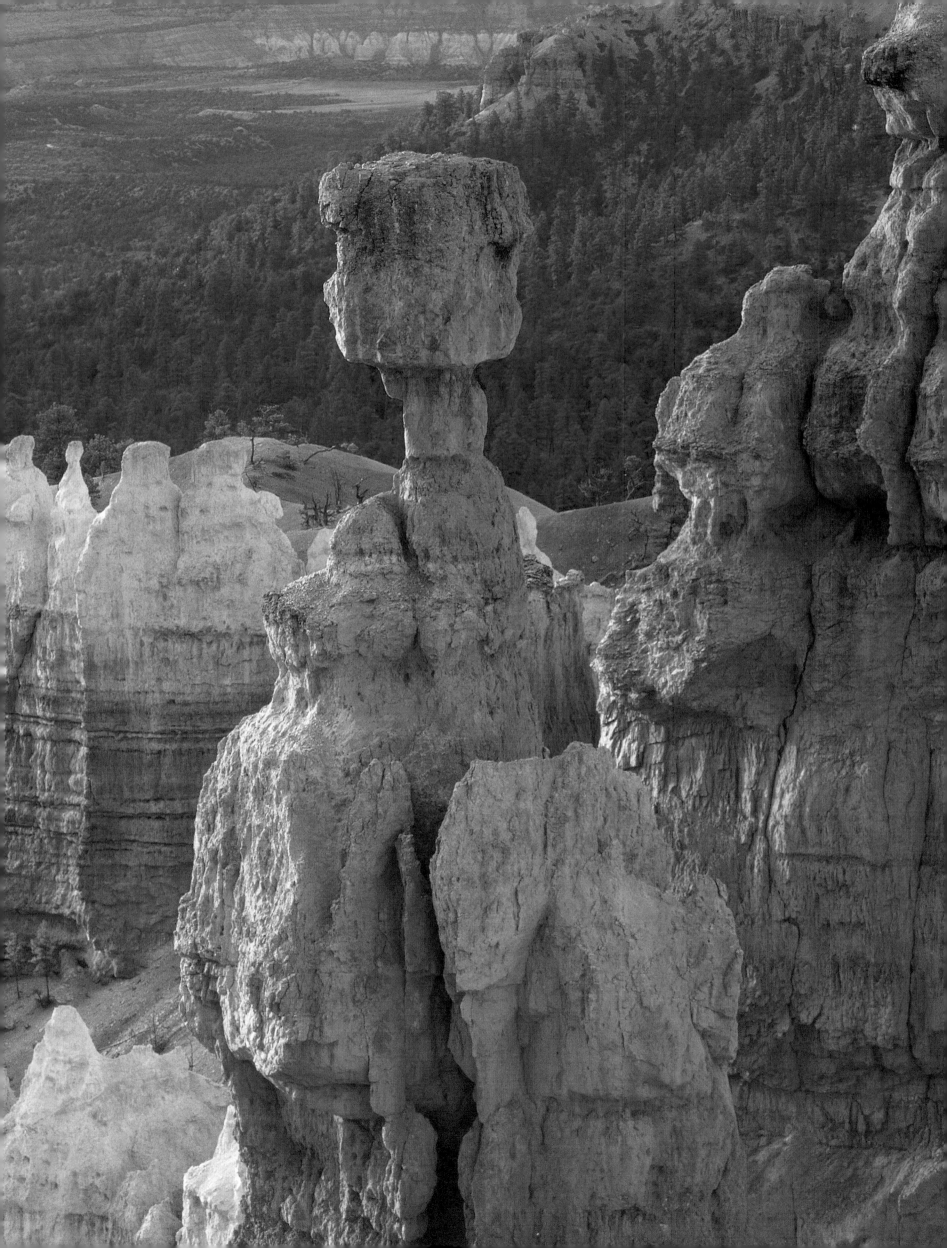

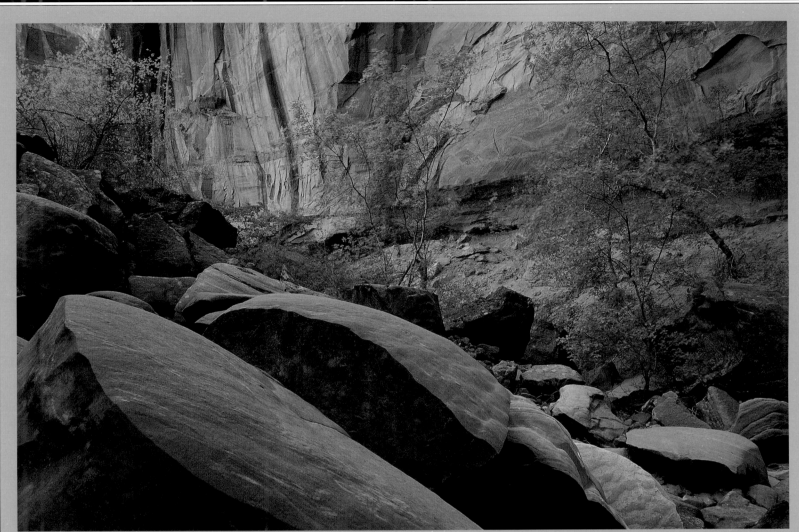

Alcove beneath Escalante Natural Bridge, Grand Staircase–Escalante National Monument.

GRAND STAIRCASE-ESCALANTE

The first attempt to preserve the vast region of the Escalante came in 1936 when the seven-million-acre Escalante National Park was proposed, then defeated. Later, fragments were added to smaller parks, but it wasn't until 1996, when President Clinton set aside Grand Staircase–Escalante National Monument, that these magnificent lands finally received protection.

The monument, the nation's first administered by the Bureau of Land Management, safeguards 1.9 million acres of the Colorado Plateau's raw beauty, and fills nearly the entire view from Bryce. From the base of Table Cliff Plateau, the monument's boundary snakes south along the bottom of Bryce, hugs the southern horizon, winds northeast along the Escalante River (beyond the eastern horizon) to join Capitol Reef National Park, and wiggles back to Table Cliff Plateau along the Aquarius Plateau's foundation. Within its wild embrace lie smooth slickrock narrows, bowed arches, redrock canyons where wiry coyotes trot and where ancient voices linger, plateaus of solitude, and magic.

Within this panorama lie two of the monument's three sections. The Grand Staircase, a series of stepped cliffs, descends from the 9,000-foot Pink Cliffs of Bryce, through the Grey, White, Vermilion, and Chocolate Cliffs, ending 2,000 feet lower at the Grand Canyon's north rim.

The monument's middle section, the high, austere Kaiparowits Plateau, is visible on the eastern horizon's sharp edge. Called *Wild Horse Mesa* by the writer of westerns Zane Grey in 1924, the Kaiparowits was to him the embodiment of wild nature, remote solitude, and grand adventure—and to many, it still is. Beyond the Kaiparowits lies the Escalante River's intricate redrock maze, where scarlet monkey flower reflects on delicate waters and ancient stone granaries murmur on the canyon breeze.

Opportunities to find your own wild adventure abound in the Grand Staircase–Escalante: hike for an hour or a month, ride mountain bikes or horses, or drive to a remote spot and camp in the rapture of a star-filled night. Visitor information is available at Bureau of Land Management offices in Kanab and Escalante, at the Paria Contact Station on Highway 89, and at the monument's Web site at: www.ut.blm.gov/monument. Check with monument staff before attempting unpaved roads and routes, and be prepared for a Zane Grey adventure full of self-reliance and the peace of remote solitude.

RESOURCES & INFORMATION

EMERGENCY & MEDICAL:
24-HOUR EMERGENCY MEDICAL SERVICE
Dial 911, or (435) 676-2411 (County Sheriff)

ROAD CONDITIONS:
ARIZONA	(520) 779-2711
COLORADO	(303) 639-1111
NEVADA	(702) 486-3116
NEW MEXICO	(800) 432-4269
UTAH	(801) 964-6000

FOR MORE INFORMATION:
NATIONAL PARKS ON THE INTERNET:
www.nps.gov

BRYCE CANYON NATIONAL PARK
PO Box 170001
Bryce Canyon, UT 84717-0001
(435) 834-5322
www.nps.gov/brca

BRYCE CANYON NATURAL HISTORY ASSOC.
Bryce Canyon, UT 84717
(888) 362-2642

BUREAU of LAND MANAGEMENT
176 East DL Sargent Drive
Cedar City, UT 84720
(435) 586-2401
www.blm.gov

COLOR COUNTRY TRAVEL REGION
PO Box 1550
St. George, UT 84771
(800) 233-8824
www.utahscolorcountry.org

DIXIE NATIONAL FOREST
82 North 100 East
Cedar City, UT 84720
(435) 865-3700
www.fs.fed.gov

UTAH STATE PARKS
1636 West North Temple
Salt Lake City, UT 84116
(801) 538-7220
www.nr.state.ut.us/parks/utahstpk.htm

UTAH TRAVEL COUNCIL
Council Hall/Capitol Hill
Salt Lake City, UT 84114
(800) 200-1160
www.utah.com

LODGING INSIDE THE PARK:
AMFAC PARKS & RESORTS
14001 E. Iliff, Suite 600
Aurora, CO 80014
(303) 29 -PARKS
www.amfac.com

CAMPING INSIDE THE PARK:
Phone: (800) 365-CAMP (2267).
On the Internet: www.reservations.nps.gov

LODGING OUTSIDE THE PARK:
On the Internet: www.brycecanyon.net

COLOR COUNTRY TRAVEL REGION
PO Box 1550
St. George, UT 84771
(800) 233-8824
www.utahscolorcountry.org

GARFIELD COUNTY TRAVEL COUNCIL
PO Box 200
Panguitch, UT 84759
(800) 444-6689

KANE COUNTY TRAVEL COUNCIL
78 South 100 East
Kanab, UT 84741
(800) 733-5263
www.kaneutah.com

OTHER REGIONAL SITES:
ANASAZI STATE PARK
PO Box 1429
Boulder, UT 84716
(435) 355-7308

CEDAR BREAKS NATIONAL MONUMENT
PO Box 749
Cedar City, UT 84720
(435) 586-9451

ESCALANTE PETRIFIED FOREST STATE PARK
PO Box 350
Escalante, UT 84726
(800) 322-3770

FREMONT INDIAN STATE PARK
11550 Clear Creek Canyon Rd.
Sevier, UT 84766
(435) 527-4631

GLEN CANYON NATIONAL RECREATION AREA
PO Box 1507
Page, AZ 86040
(520) 645-2471

GRAND STAIRCASE–ESCALANTE NAT'L MONU.
PO Box 246
Escalante, UT 84726
(435) 826-5499

LAKE MEAD NATIONAL RECREATION AREA
601 Nevada Highway
Boulder City, NV 89005-2426
(702) 293-8907

MESA VERDE NATIONAL PARK
Mesa Verde National Park, CO 81330
(970) 529-4461

MONUMENT VALLEY NAVAJO TRIBAL PARK
PO Box 360289
Monument Valley, UT 84536
(435) 727-3353 or 727-3287

NAVAJO NATIONAL MONUMENT
HC 71, Box 3
Tonalea, AZ 86044-9704
(520) 672-2366 or 672-2367

PETRIFIED FOREST NATIONAL PARK
PO Box 217
Petrified Forest, AZ 86028
(520) 524-6228

PIPE SPRING NATIONAL MONUMENT
HC 65, Box 5
Fredonia, AZ 86022
(520) 643-7105

WUPATKI & SUNSET CRATER
NATIONAL MONUMENTS
2717 N. Steves Blvd., Suite 3
Flagstaff, AZ 86004
(520) 556-7042

ZION NATIONAL PARK
Springdale, UT 84767
(435) 772-3256

SUGGESTED READING:
Abbey, Edward. *DESERT SOLITAIRE*. (1968). Reprint. New York, NY: Ballantine Books. 1971.

Buchanan, Dr. Hayle. *WILDFLOWERS OF SOUTH-WESTERN UTAH: A Field Guide to Bryce Canyon, Cedar Breaks and Surrounding Plant Communities*. Bryce Canyon, UT: Bryce Canyon Natural History Association. 1997.

Chesher, Greer K. *GRAND STAIRCASE–ESCALANTE NATIONAL MONUMENT: Heart of the Desert Wild*. Bryce Canyon, UT: Bryce Canyon Natural History Association. 2000.

DeCourten, Frank. *SHADOWS OF TIME: The Geology of Bryce Canyon National Park*. Bryce Canyon, UT: Bryce Canyon Natural History Association. 1994.

Dykinga, Jack & Bowden, Charles. *STONE CANYONS OF THE COLORADO PLATEAU*. New York, NY: Harry N. Abrams, Inc. 1996

Leach, Nicky. *CEDAR BREAKS NATIONAL MONUMENT*. Springdale, UT: Zion Natural History Association. 1996

Nicholas, Jeff & Wilson, Jim & Lynn. *ISLANDS IN THE SKY: SCENES FROM THE COLORADO PLATEAU*. Mariposa, CA: Sierra Press. 1991

Stegner, Wallace. *BEYOND THE HUNDREDTH MERIDIAN*. New York, NY: Penguin Books. 1992

Stouffle, Richard W. and Michael J. Evans. *KAIBAB PAIUTE HISTORY: The Early Years*. Fredonia, AZ: Kaibab Indian Tribe. 1978.

Stroud, Tully. *THE BRYCE CANYON AUTO AND HIKING GUIDE*. Bryce Canyon, UT: Bryce Canyon Natural History Association. 1983.

Telford, John & Williams, Terry Tempest. *COYOTE'S CANYON*. Salt Lake City, UT: Peregrine Smith Books. 1989

ACKNOWLEDGMENTS:

Special thanks to Gayle Pollock, Paula Henrie, and LaKay Quilter at Bryce Canyon Natural History Association, Jan Stock and the staff of Bryce Canyon National Park, and all the talented photographers who made their imagery available for use in this book. —JDN

PRODUCTION CREDITS:

Publisher: Jeff D. Nicholas
Author: Greer K. Chesher
Editor: Nicky Leach
Illustrations: Darlece Cleveland
Printing Coordination: Sung In Printing America

COPYRIGHT 2000 BY:
Panorama International Productions, Inc.
4988 Gold Leaf Drive
Mariposa, CA 95338

Sierra Press is an imprint of
Panorama International Productions, Inc.

Printed in the Republic of South Korea.
First printing, Spring 2000.
Second printing, Spring 2002.

SIERRA PRESS

4988 Gold Leaf Drive
Mariposa, CA 95338
(209) 966-5071, 966-5073 (Fax)
e-mail: siepress@yosemite.net

VISIT OUR WEBSITE AT:
www.nationalparksusa.com

SIERRA PRESS
MARIPOSA, CA

OPPOSITE:
The view from Sunset Point, winter morning.
PHOTO © DICK DIETRICH

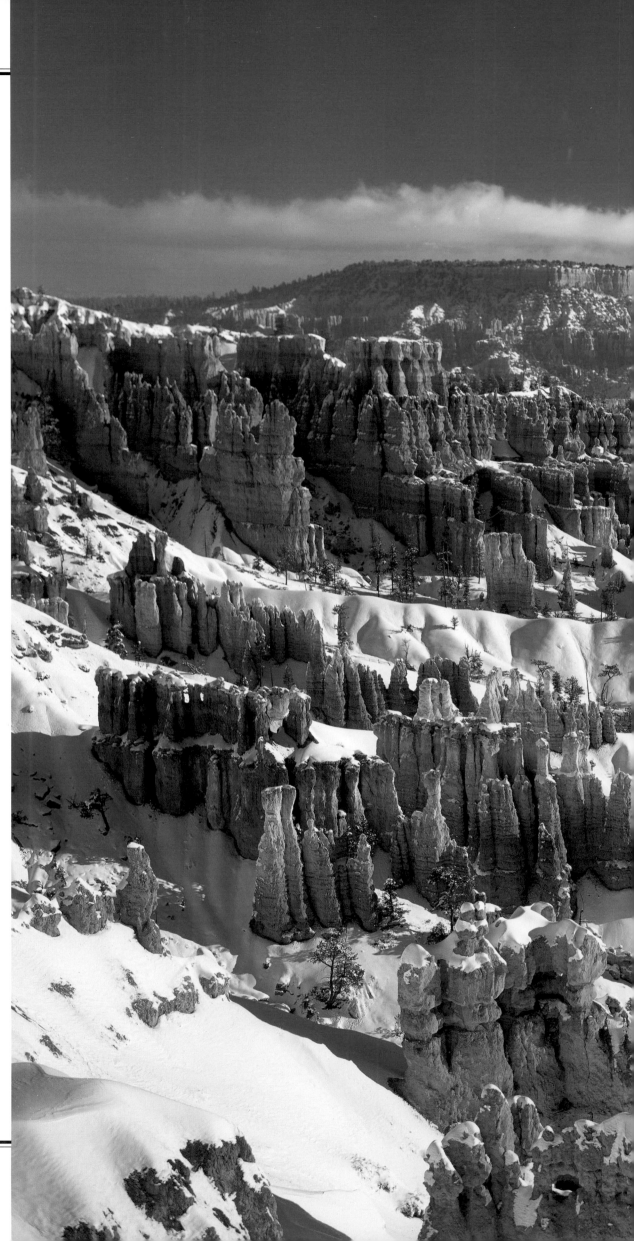